THE ART OF
fashion
TANGLING

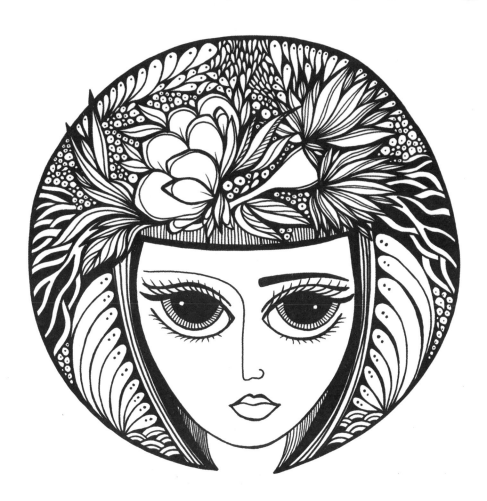

Quarto is the authority on a wide range of topics.
Quarto educates, entertains, and enriches the lives of our readers—
enthusiasts and lovers of hands-on living.
www.quartoknows.com

© 2016 Quarto Publishing Group USA Inc.
Published by Walter Foster Publishing,
a division of Quarto Publishing Group USA Inc.

Project Editor: Stephanie Carbajal
Page Layout: Erin Fahringer

Photograph on page 7 © Shutterstock. Artwork on page 8 © 2009 Eileen Sorg. Artwork on front cover and pages 12, 17, and 30–59 © 2013, 2016 Norma J. Burnell. Artwork on pages 9–11, 13–14, 16, 18–23, 118–123, and border designs © 2013, 2015, 2016 Penny Raile; photographs on pages 120–121, and 123 by Pauline Molinari. Artwork on page 15 © 2013 Margaret Bremner. Artwork on pages 60–81, 140–143 © 2016 Heidi Cogdill. Artwork on pages 3 and 82–103 © 2016 Jill Buckley. Artwork on back cover and pages 1 and 104–117 © 2016 Jody Pham. Artwork and photographs on pages 124–133 © 2016 Monica Moody, except photographs on pages 127 and 133 by Pauline Molinari. Artwork and photographs on pages 136–139 © 2016 Lisa-Mari Grytten. Artwork on pages 24–29 © 2011 Stephanie Corfee.

6 Orchard Road, Suite 100
Lake Forest, CA 92630
quartoknows.com
Visit our blogs @quartoknows.com

Printed in China
1 3 5 7 9 10 8 6 4 2

Table of Contents

Introduction: A Passion for Fashion

Like art, fashion tells a story. Line, texture, pattern, and color—they all craft a tale of couture. One of the beautiful things about fashion is its ever-evolving nature, which is why tangling and doodling are the perfect complement: These art forms are about experimenting, exploring, and pushing the boundaries—like fashion itself.

Welcome to **The Art of Fashion Tangling!** From learning to draw basic tangles and unique patterns to exploring the world of fashion through a doodler's eyes, innovation and inspiration abound in this guided journey.

You don't need any special expertise to tangle and doodle. Many of the projects inside this book focus on repeating patterns and motifs, which look complex but are actually quite simple. The key is to play, have fun, and let your creativity flow.

After learning about a few basic tools and materials, you'll be invited to explore the fascinating world of fashion as defined by seven talented artists. From doodling dresses, gowns, hats, and shoes to creating wildly whimsical hairstyles and learning to tangle bracelets, necklaces, leather cuffs—even fingernails!—you are sure to enjoy the fun, eclectic mix of projects, step-by-step drawing lessons, and creative exercises in this engaging book. Artist tips, blank templates, and open practice areas invite interaction and creativity on nearly every page. Before you know it, you'll have your very own tangled and doodled collection of fabulous fashions!

Let's get started!

What is Tangling?

Originally developed by Rick Roberts and Maria Thomas, Zentangle®, or Tangling, is a fun, contemplative, relaxing art form that employs structured and coordinated patterns as a means of creating beautiful and interesting pieces of art. Tangling focuses on the process of art creation rather than the end result. Its approach involves drawing each stroke deliberately and consciously, without worrying about or concentrating on the final outcome. The journey is in the process, and there is no right way or wrong way. If you can put pencil or pen to paper, you can tangle. This book combines traditional tangling with free-form doodling for an especially fun and exciting artistic adventure.

Tangling Terms

Border – An outline along the outer edges of the tile, enclosing the tangle inside the frame.

Mosaic – The joining of two or more tangle tiles to create a larger piece of artwork.

String – A random pencil line that serves as the guide upon which to tangle.

Tangle – The word "tangle" functions as both a verb and a noun. As a verb, "tangle" relates to the act of creating a work of tangled art (e.g., "I am going to tangle today"). As a noun, "tangle" refers to the pattern created following the prescribed method.

Tile – A 3½- x 3½-inch quality archival paper upon which one tangles. Tiles can then be arranged into larger mosaics.

Tools & Materials

All you really need to tangle and doodle is paper, a pen, and a pencil; however, there are a few additional materials you may want to have handy as you begin your artistic adventure.

Sketch Pads and Drawing Paper

Sketch pads come in many sizes and are great for tangling on the go. There are a variety of quality drawing papers to choose from. Visit your local art supply store to see which type you prefer.

Smooth and Vellum Bristol Board

Both of these Bristol board types work well for tangling. Experiment to see which works best for you.

Hot-pressed Watercolor Paper

This paper's untextured surface lends itself well to illustration and small details.

Pencils

In tangling, pencils are used to draw strings, create borders, and add shading. Pencils are designated by hardness and softness. H pencils are hard and make lighter marks; B pencils are soft and make darker marks. Pencils range from very soft (9B) to very hard (9H). You can also use standard No. 2 and No. 4 pencils.

Blending Stumps

Blending stumps allow you to blend or soften lines and areas in your tangles and doodles.

Sharpener

You can achieve various effects depending on the sharpness of your pencil, but generally you'll want to keep your pencil well sharpened.

Erasers

There are no mistakes in tangling and doodling, making erasers unnecessary; however, when creating some types of art, you may want to erase old sketch lines to clean up your final artwork. Kneaded erasers can be shaped into a fine point or used over broad surfaces. They leave no dust and are great for lifting out highlights. Vinyl erasers are great for removing graphite without chewing up the paper.

Archival Ink Pens

Tanglers typically use archival ink pens to render their finished artwork. It's helpful to have a selection of pens in every point size. Take time to familiarize yourself with these pens before getting started. Pens are typically numbered as follows:

005 pen	=	0.20 mm point
01 pen	=	0.25 mm point
02 pen	=	0.30 mm point
03 pen	=	0.35 mm point
05 pen	=	0.45 mm point
08 pen	=	0.50 mm point

Colored Pencils

Colored pencils are a convenient and easy method to add color. Professional-grade colored pencils have a waxy, soft lead that is excellent for shading and building up layers of color. Watercolor pencils are another excellent choice for adding touches of color to your artwork.

Gel Pens

Gel pens consist of pigment suspended in a water-based gel. They deliver thick, opaque color and work easily on dark or previously colored surfaces. They are perfect for adding details and accents in your illustrations.

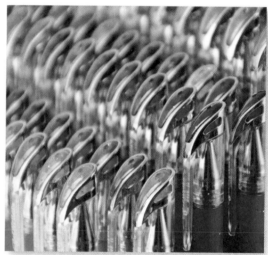

Art Markers

Professional art markers create bold, vibrant bands of color. They are great for laying down large areas of even color, as well as for shading.

How to Use a Light Box

A light box is a useful and generally inexpensive tool (although there are fancier, professional-grade versions). As its name suggests, a light box is a compact box with a transparent top and light inside. The light illuminates papers placed on top, allowing dark lines to show through for easy tracing. Simply tape your rough drawing on the surface of the light box. Place a clean sheet of paper over your original sketch and turn the box on. The light illuminates the drawing underneath and will help you accurately trace the lines onto the new sheet of paper. You can also create a similar effect by placing a lamp under a glass table or taping your sketch and drawing paper to a clear glass window and using natural light.

Getting Started

Just for fun, warm up your hand by drawing several random lines, scribbles, and squiggles.

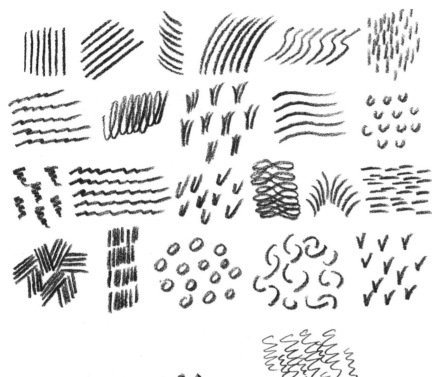

Known as "stippling," applying small dense dots is commonly used when embellishing tangles. Make the points different sizes to create various effects.

Warm up here!

Basic Tangles

Tangling is the use of repetitive patterns to make art. Through the use of repetitive patterns, you can create artwork that looks complex but is easy and simple to produce. Practice these basic tangles, following the progression of each new step; then try creating some of your own.

Flux

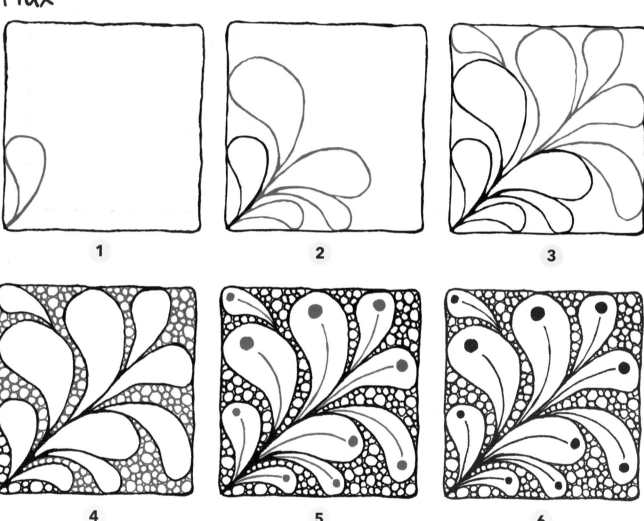

1

2

3

4

5

6

Tip
Don't worry about making things perfect. Experiment, create your own tangles and doodled designs, and just have fun!

Hollibaugh

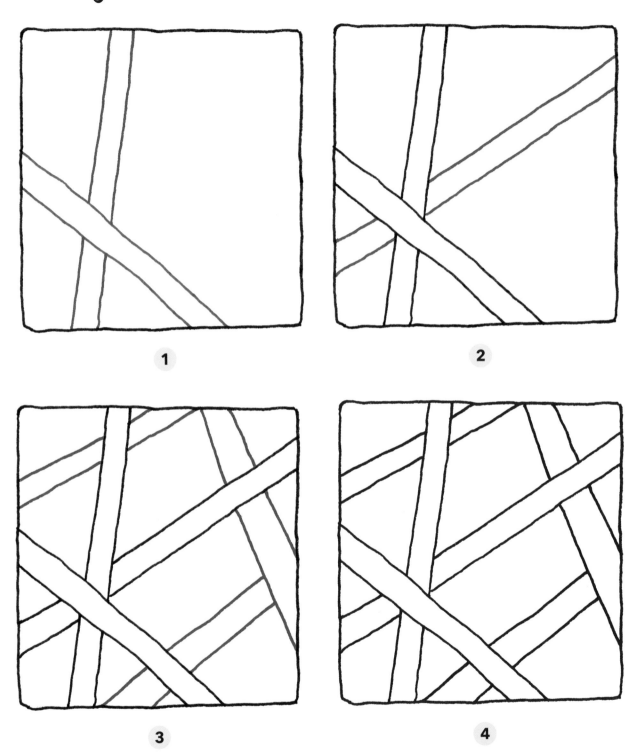

Roxi

1

2

3

4

Pokeleaf

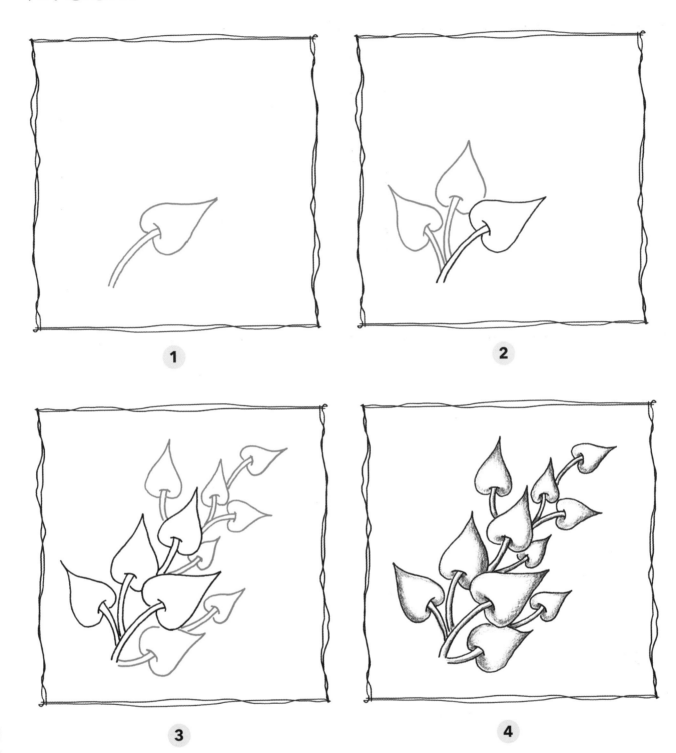

1

2

3

4

W2 Pattern

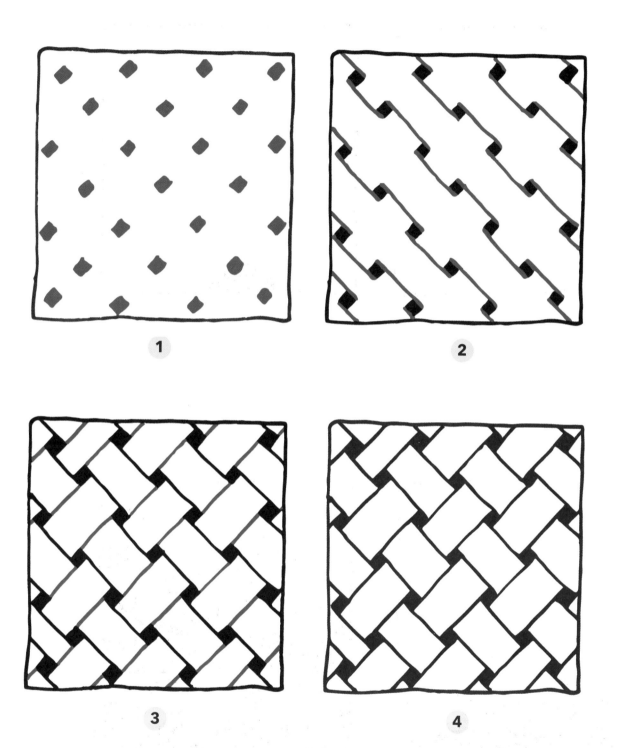

1

2

3

4

Saturn

1

2

3

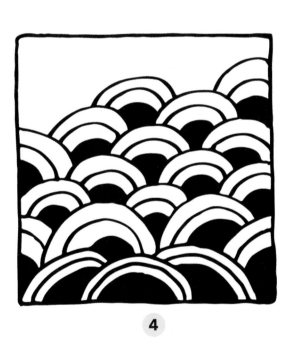

4

Printemps

1

2

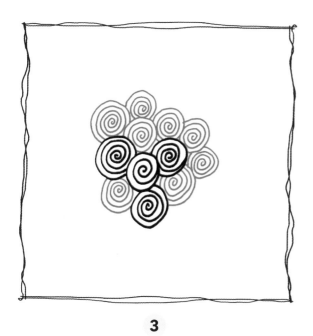

3

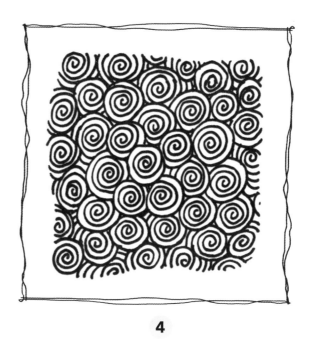

4

15

Bales Pattern

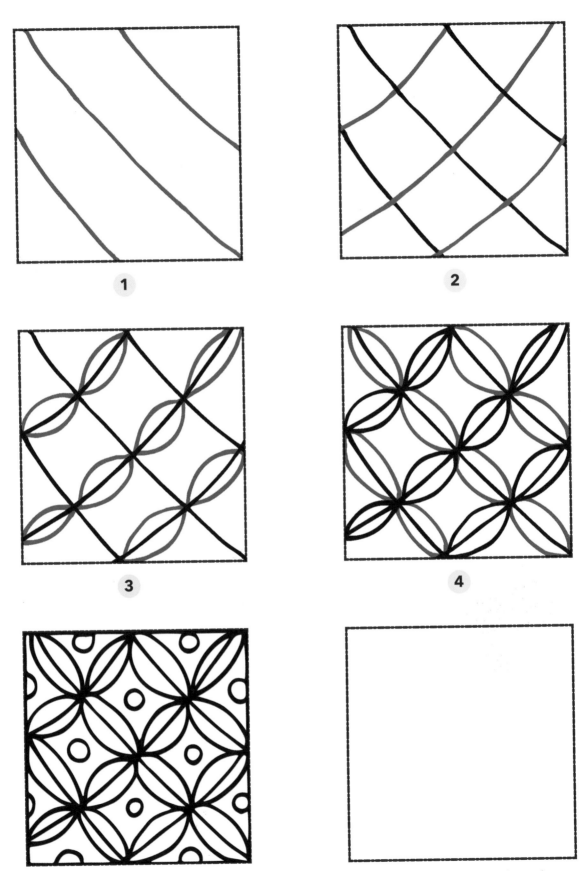

1

2

3

4

5

Now give it a try here!

Embellishments

Embellishments, also called Enhancements in tangling, can be added to your tangles and doodles to add character. You can use them alone or combine them with other tangles and doodles. Practice drawing these embellishments in the blank squares provided.

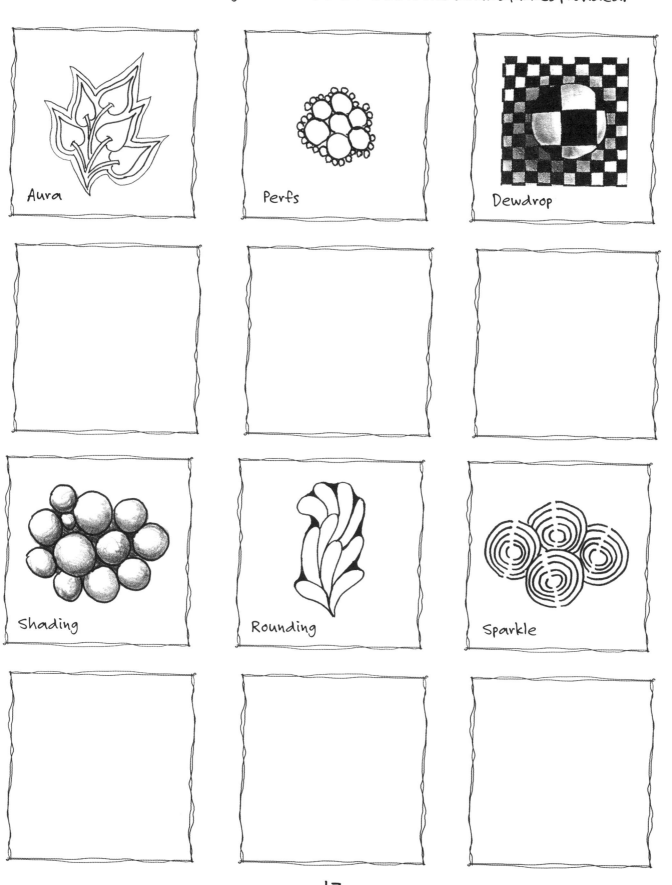

Aura

Perfs

Dewdrop

Shading

Rounding

Sparkle

Pretty Patterns

Here are some patterns to explore and practice.

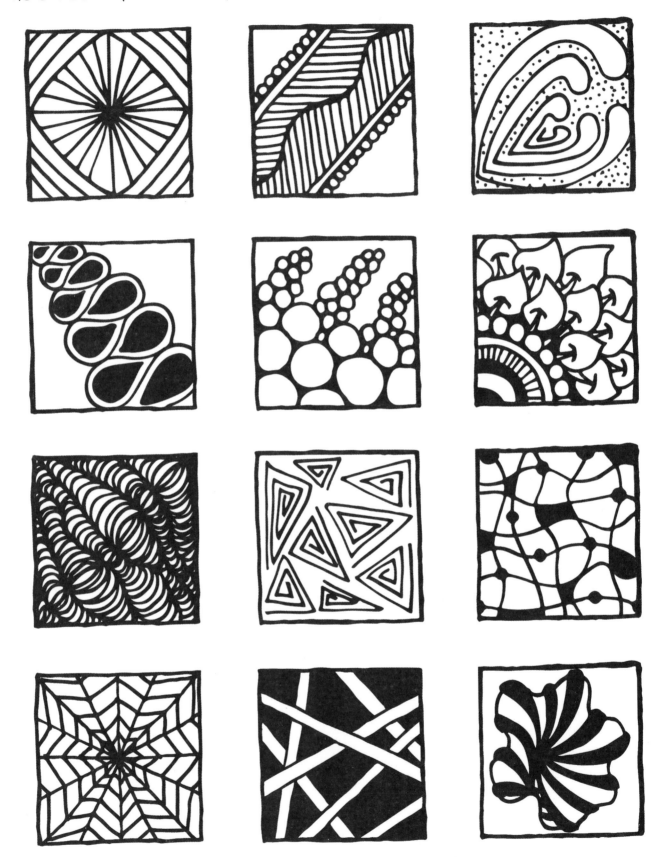

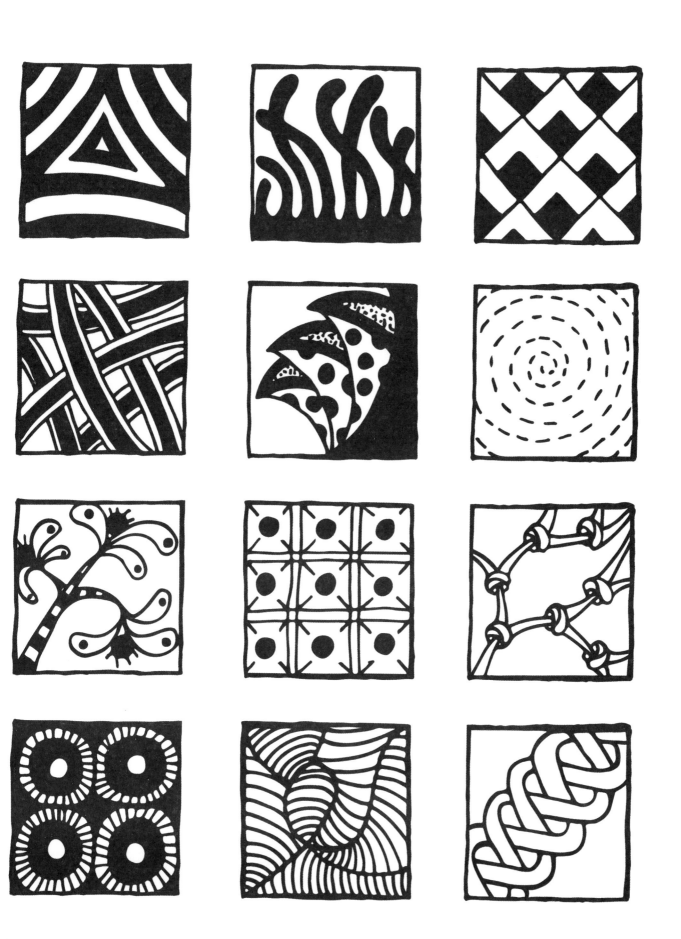

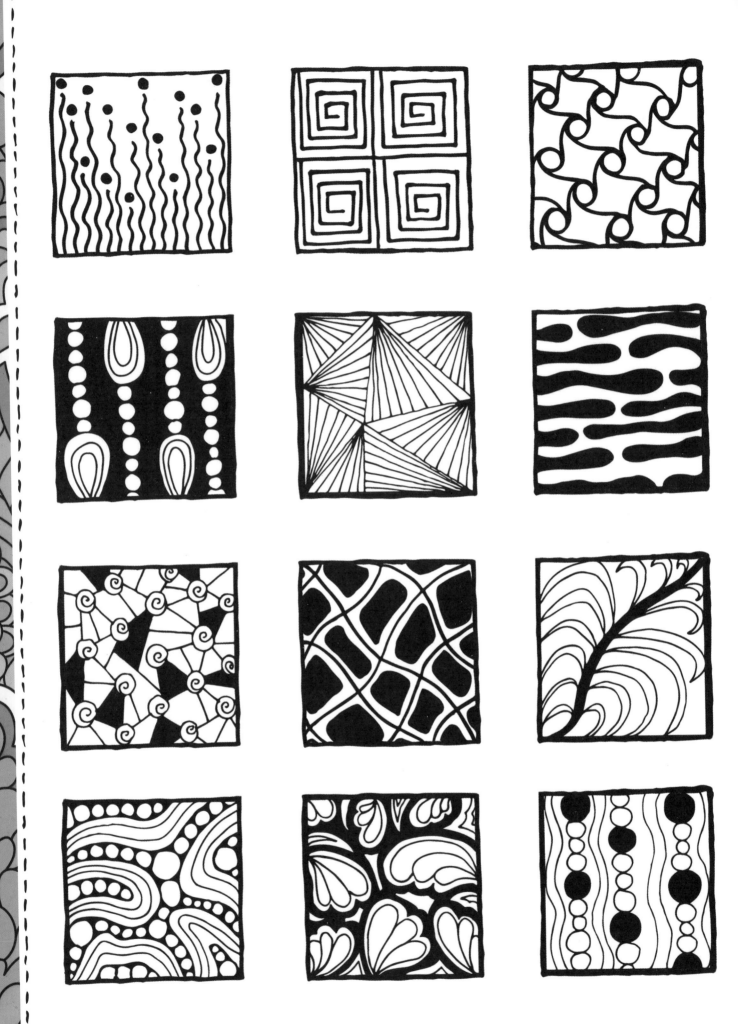

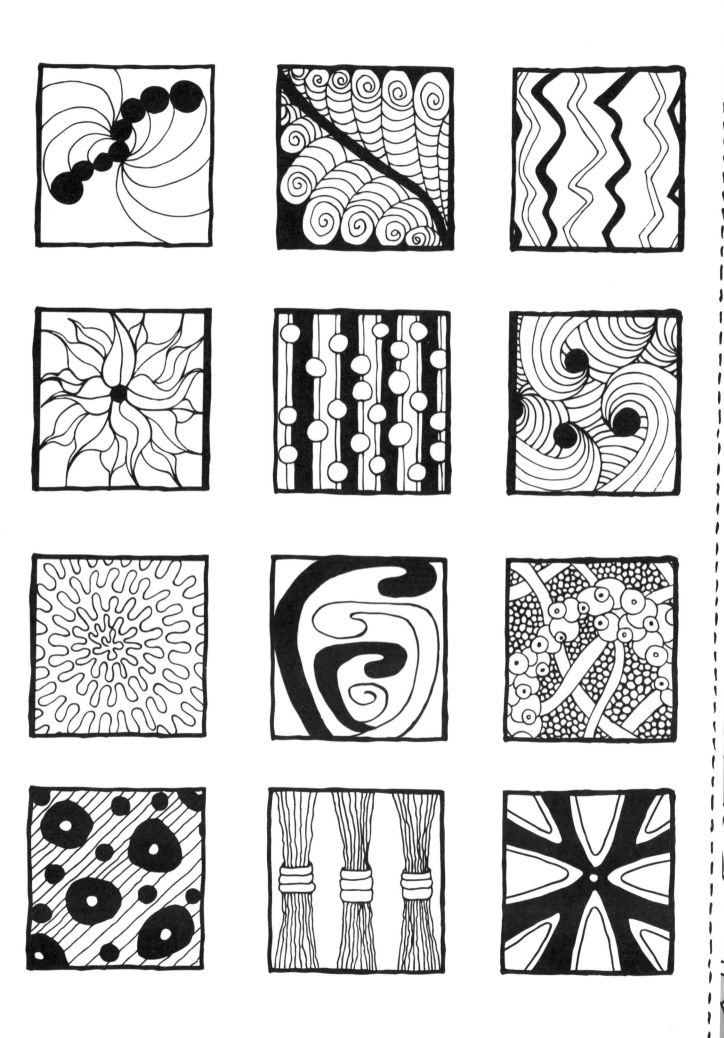

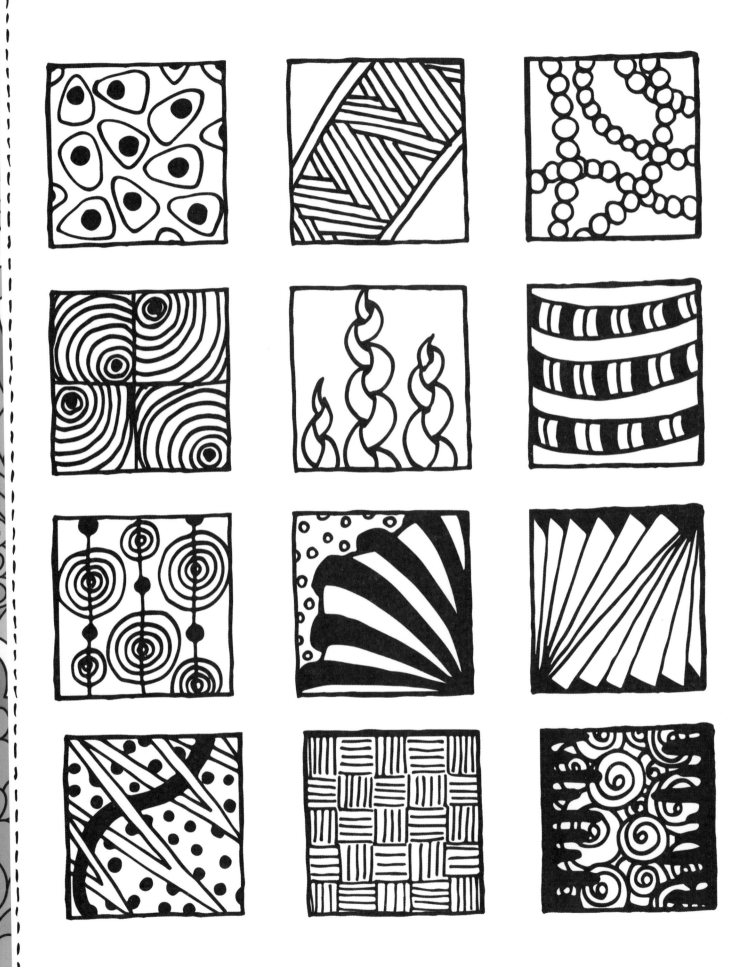

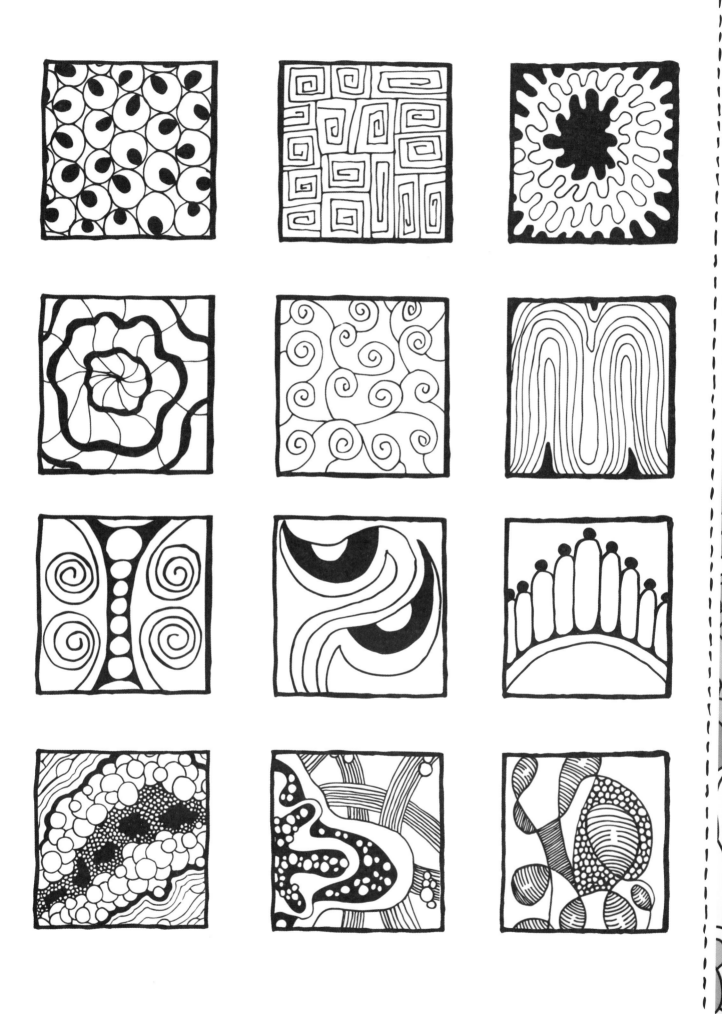

Fashion 101

There is no limit to creativity when it comes to tangled and doodled fashion—use bold color, mix patterns, and play with scale. Eventually, you'll find your personality and signature style showing through! On the following pages, you'll find some basic garments and accessories to inspire you in your exploration of fashion tangling and doodling.

Tops, Tees & Tanks

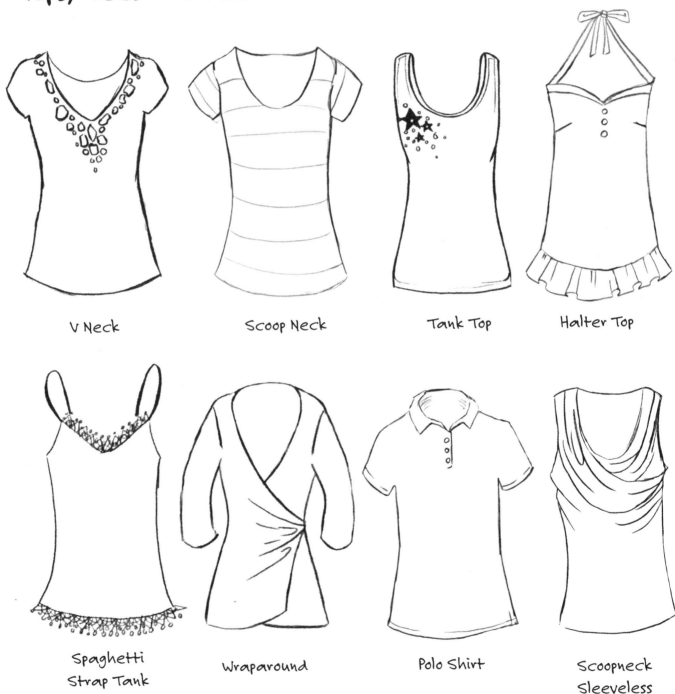

V Neck

Scoop Neck

Tank Top

Halter Top

Spaghetti Strap Tank

Wraparound

Polo Shirt

Scoopneck Sleeveless

Jeans, Pants & Shorts

Denim Cutoffs

Cuffed

Drawstring

Sweat Shorts

Capris

Straight-Leg Jeans

Distressed Jeans

Bootcut Jeans

Skirts & Dresses

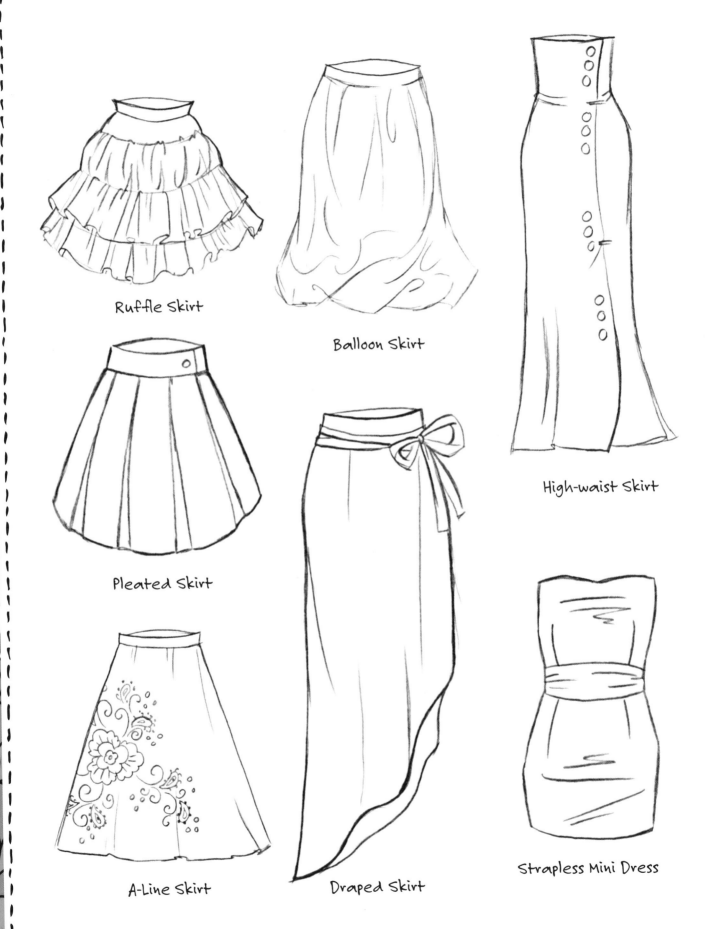

Ruffle Skirt

Balloon Skirt

High-waist Skirt

Pleated Skirt

A-Line Skirt

Draped Skirt

Strapless Mini Dress

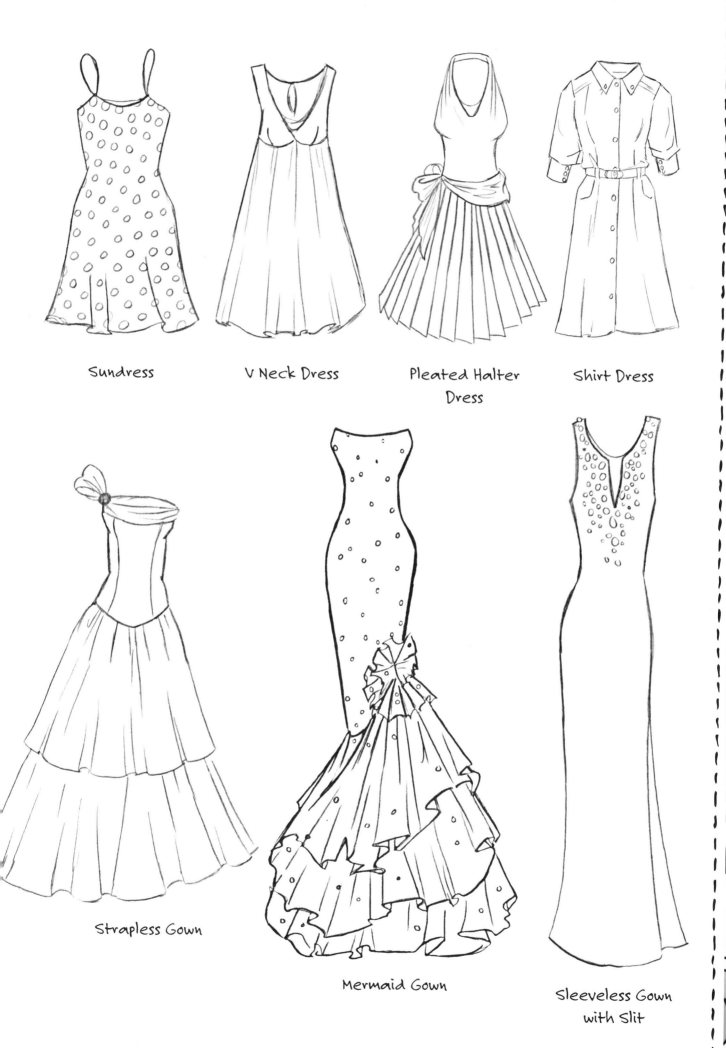

Sundress

V Neck Dress

Pleated Halter
Dress

Shirt Dress

Strapless Gown

Mermaid Gown

Sleeveless Gown
with Slit

Hats

Newsboy Cap

Sun Hat

Wide Brim Hat

Knit Cap

Bucket Hat

Ski Cap

Cowboy Hat

Shoes

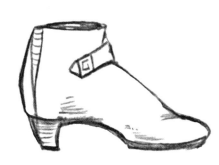

Ankle Boot

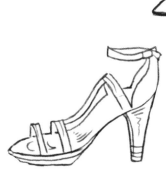

Open-toe Heel Sandal

Flats

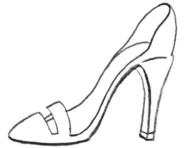

Flip-flops

Sneaker

Stiletto

Peep-toe Pump

Wedge

Knee-high Boots

Rain Boots

Fashion Tangling with Norma J. Burnell

From the moment I first discovered tangling, I was hooked. Learning this art form has opened the door to many creative possibilities in my personal artwork, particularly in my fantasy art. One of the great things about tangling is that you can incorporate it into just about any art form, including fashion design. Much like fashion, tangling holds endless opportunities for experimenting and playing with pattern, color, and line. Tangling is a process; there is no right or wrong way. It simply involves putting pen to paper one stroke at a time. So, relax, breathe, and tangle your way to the runway!

Tips

• Turn your paper. If a stroke feels awkward, try turning your paper so the stroke flows smoothly from your hand.

• Draw outside the lines. Don't be afraid to let things go in your drawing.

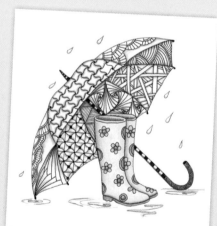

• For the best shading results, use softer lead pencils: 3B, 4B, and 5B pencils produce rich, dark tones.

• Tangle away! Remember, you can tangle on just about anything. I have a pair of white shoes that are no longer white—they've been tangled!

Fashion-spiration!

The magic of nature inspires me! Nature's treasures, from the four seasons to flowers, leaves, and branches, can serve as tangling inspiration—even in fashion design! Tangle ornate skirts and dresses with colors and patterns reminiscent of a wildflower garden. Create wild designs, drawing inspiration from the rain, clouds, rivers, oceans—even the colors of the desert. Don't limit the possibilities. Allowing your creativity to take you to new, unexplored places will result in magical, meaningful artwork!

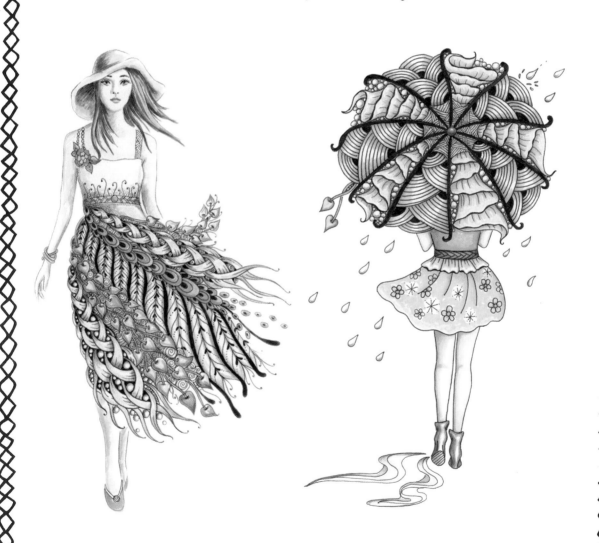

Umbrella

Umbrellas make a natural string to tangle in, just by the nature of their shape and lines. Here are a few different umbrella shapes to explore.

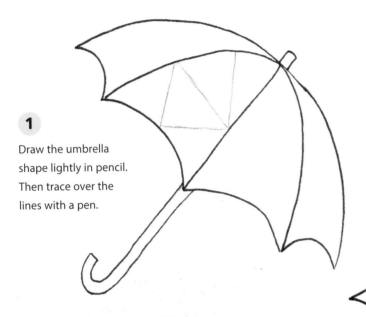

1

Draw the umbrella shape lightly in pencil. Then trace over the lines with a pen.

2

For the first tangle, I'm using Rick's Paradox. Draw several sets of triangles within triangles in the "string" of the first umbrella panel. You can also try one of your favorite tangles in this space.

Tip

To help break up the natural occurring lines of the umbrella, add more "strings"—or lines on which to tangle

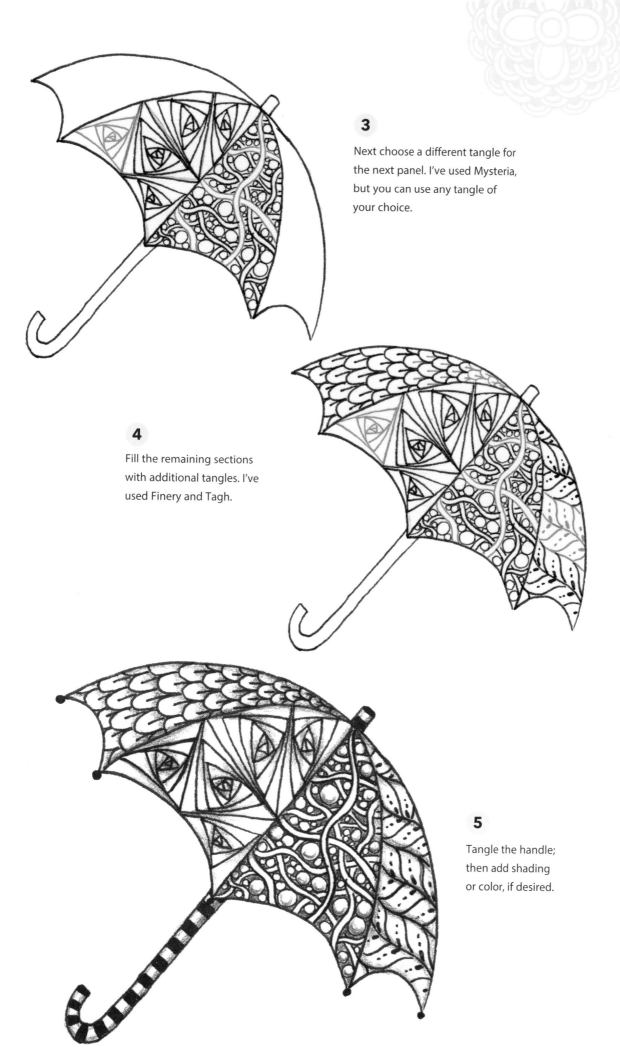

3

Next choose a different tangle for the next panel. I've used Mysteria, but you can use any tangle of your choice.

4

Fill the remaining sections with additional tangles. I've used Finery and Tagh.

5

Tangle the handle; then add shading or color, if desired.

PRACTICE HERE

Fill the umbrellas on pages 34–37 with your tangled patterns,
or photocopy them to use over and over again.

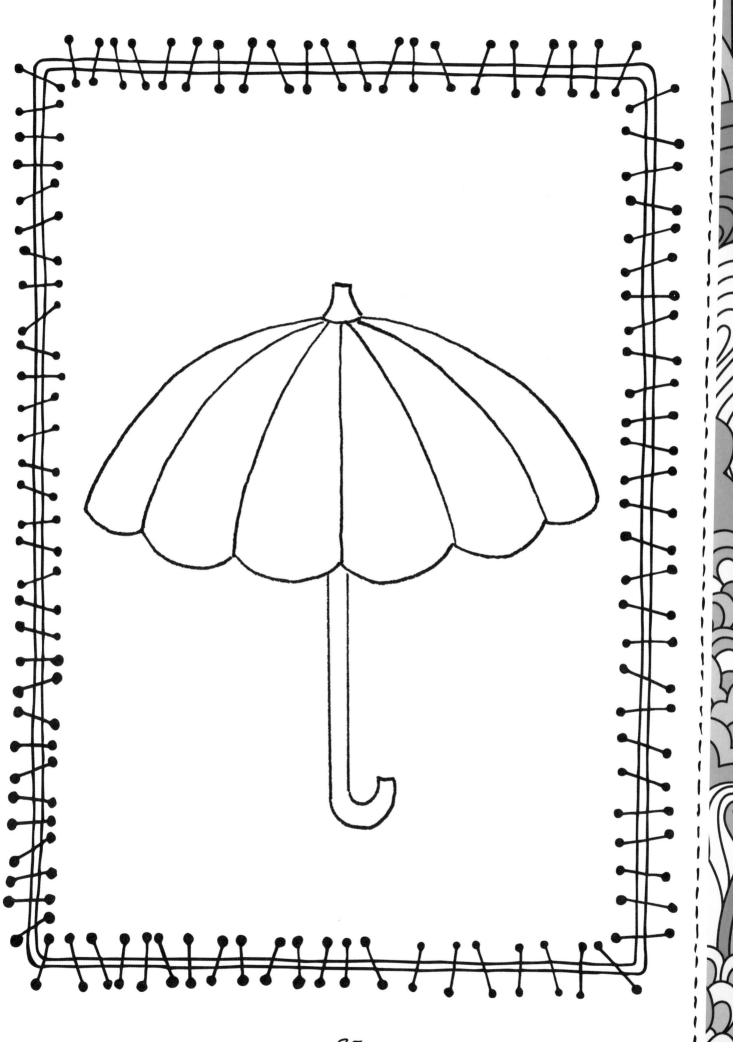

35

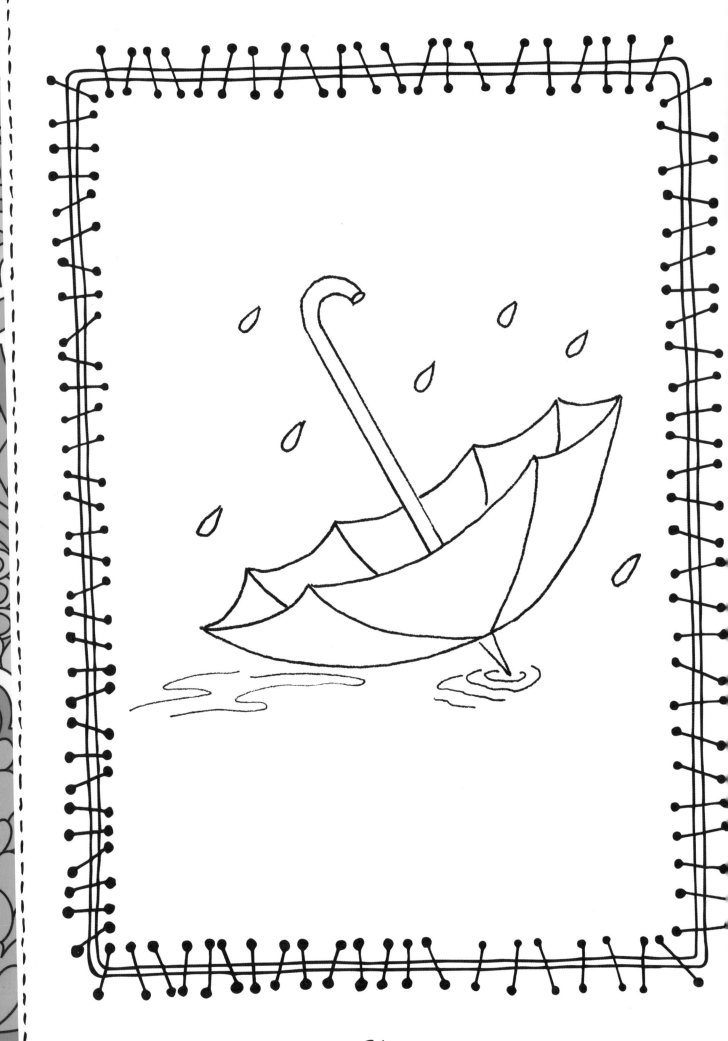

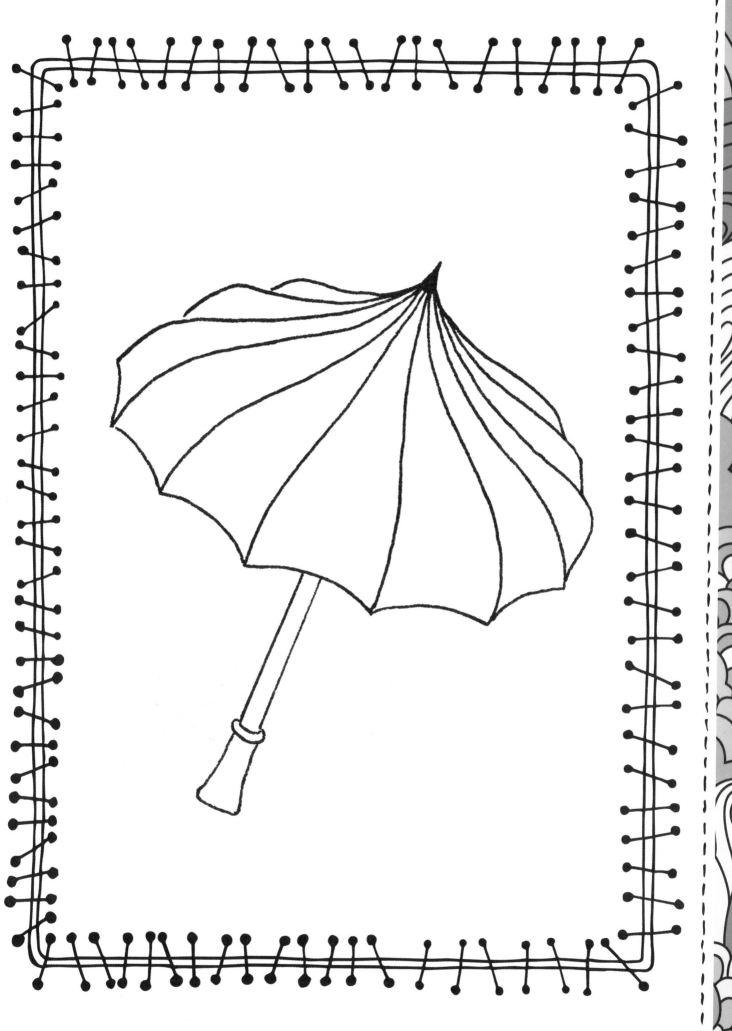

Floppy Hat

Hats—particularly the floppy kind—make wonderful shapes to tangle in. A hat can be broken down into several sections: the top, band, brim, and under the brim. You can also further break up a section by adding more strings.

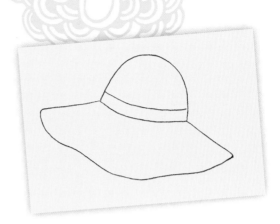

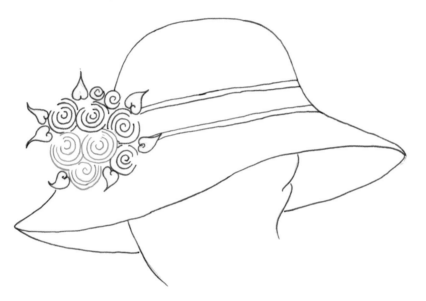

1

Draw the hat shape lightly in pencil; then trace over the lines with a pen. Begin your first tangle. I used Pintemps and Poke Leaf to achieve a flower effect. Other tangles that would work well in this spot are Poke Root, Blooming Butter, and Flux.

2

Fill the top part of the hat and the band with tangles.

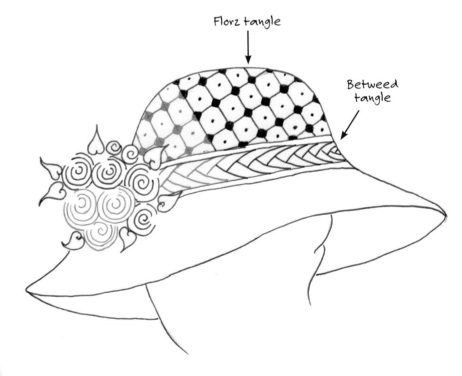

Florz tangle

Betweed tangle

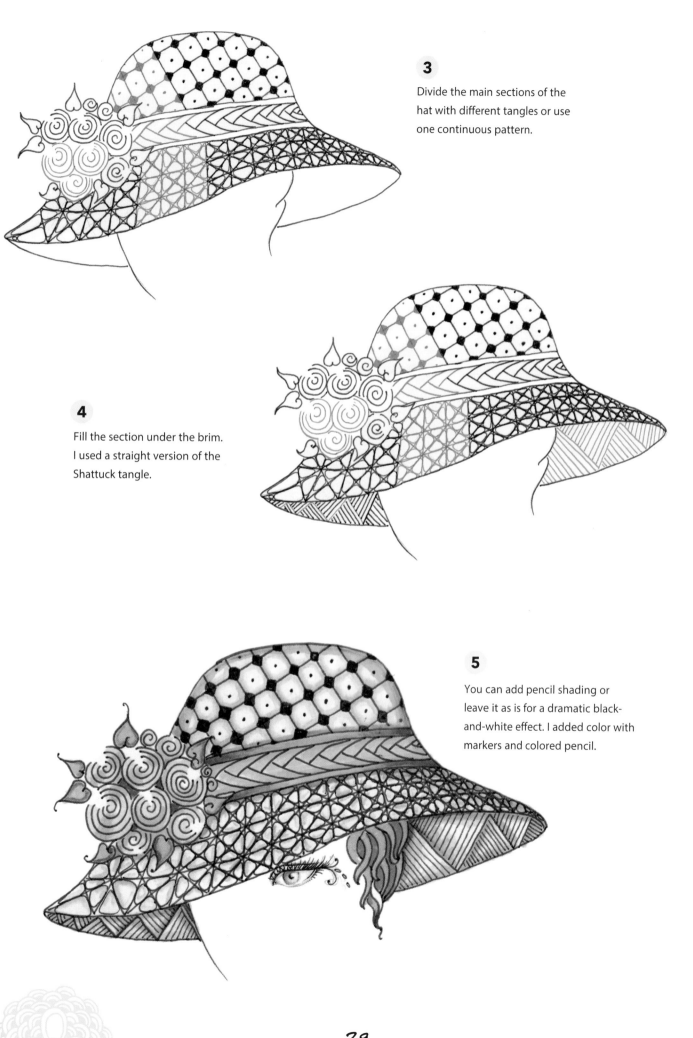

3

Divide the main sections of the hat with different tangles or use one continuous pattern.

4

Fill the section under the brim. I used a straight version of the Shattuck tangle.

5

You can add pencil shading or leave it as is for a dramatic black-and-white effect. I added color with markers and colored pencil.

Inspired Designs

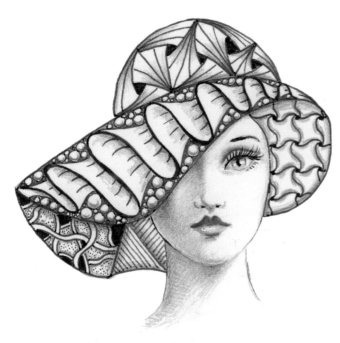

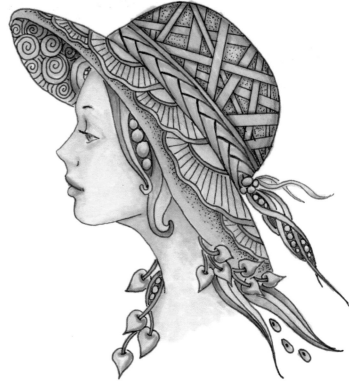

A Little Tangled Hat, 4" x 4", ink and
pencil on Bristol-weight paper
Tangles used: Ing, Cadent, Tri-Po,
Mysteria, Shattuck

Lilly's Hat, 4" x 6", ink and markers on
Bristol weight paper
Tangles used: Betweed, Sparkle,
Hollibaugh, Poke Leaf

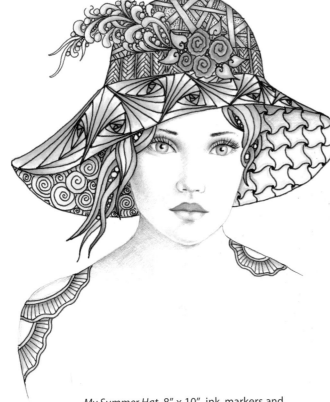

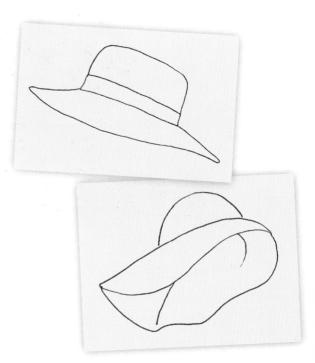

My Summer Hat, 8" x 10", ink, markers and
pencil on Bristol-weight paper
Tangles used: Cadent, Rick's Paradox,
Hollibaugh, Pintemps, Betweed, Mooka

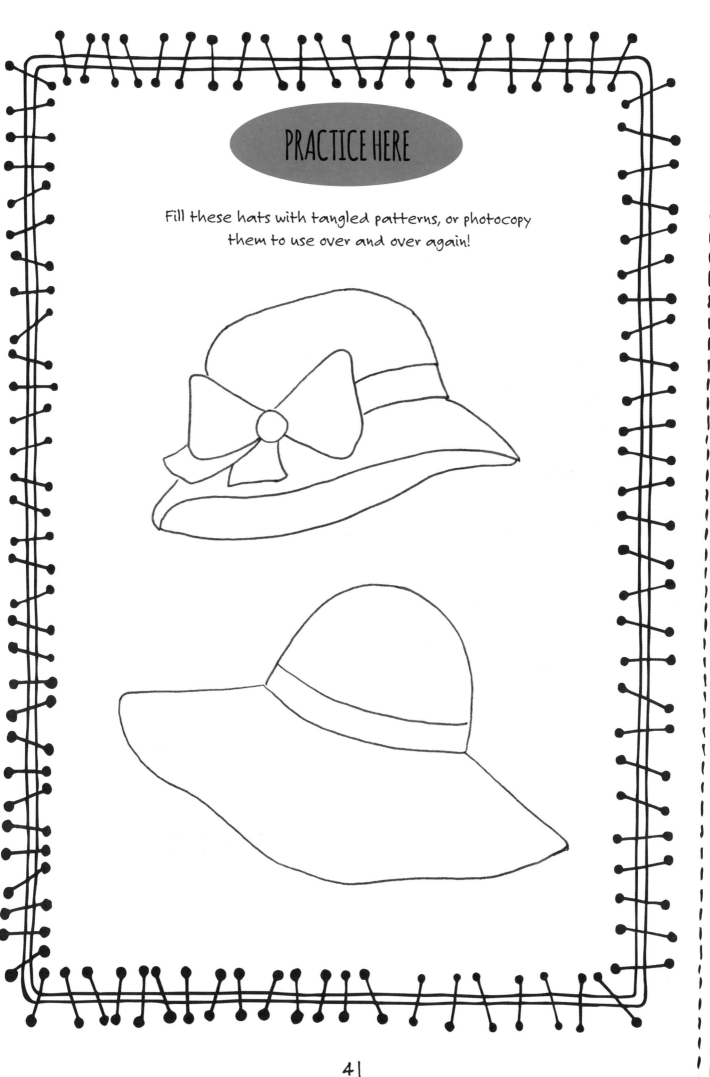

PRACTICE HERE

Fill these hats with tangled patterns, or photocopy them to use over and over again!

41

Swimsuit

Swimsuits come in all shapes and sizes, from bikinis and tanks to skirts and classic shapes. When breaking down a bathing suit into "strings" to tangle, look for the natural lines in the shape. The top, bottom, trim, and bodice can all be "strings" to tangle.

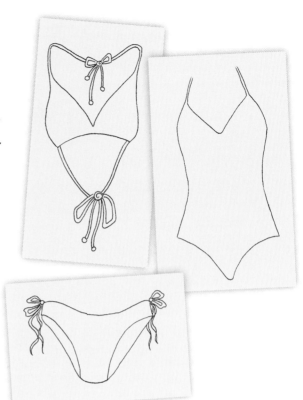

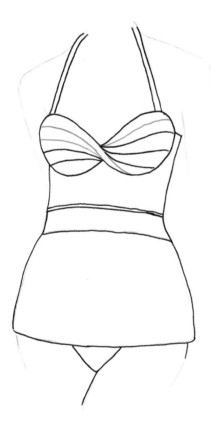

1

Start with an outline of the swimsuit, lightly in pencil. Trace the lines in pen, defining the different "strings" within the swimsuit. Then start tangling! For my first tangle, I'm using a modified version of Cool 'Sista, twisting it slightly to flow with the shape of the suit top. Other tangles that would work well here are Betweed and Flux.

2

Choose a different tangle for the next section. I'm using Nightsbridge for the belt area, but you can use any tangle of your choice.

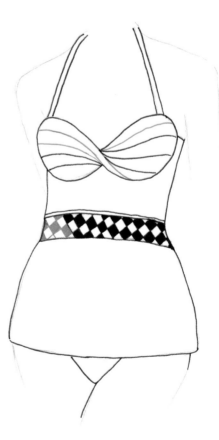

42

3

Continue to add tangles to the remaining open areas. I've used Nzepple for the skirt area, Mysteria for the bodice, and Rick's Paradox for the suit bottom.

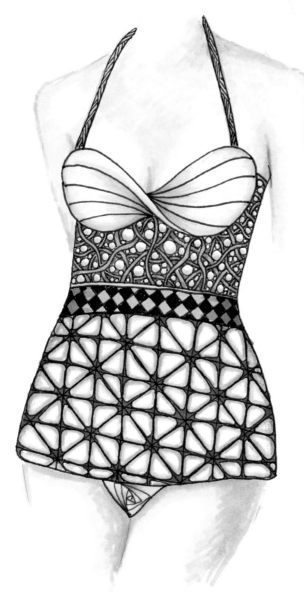

4

Add color! I used markers, but you can use your favorite medium or just add shading with pencil for a black-and-white retro effect.

PRACTICE HERE

Fill the swimsuits on pages 44-46 with your own tangled designs!

Inspired Designs

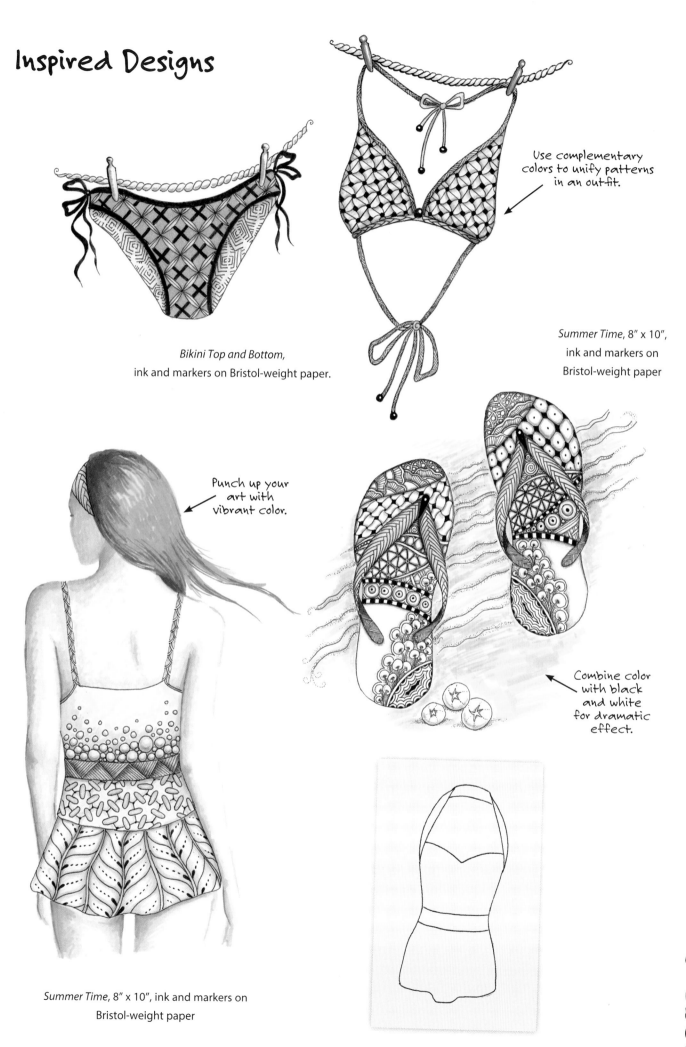

Bikini Top and Bottom,
ink and markers on Bristol-weight paper.

Use complementary colors to unify patterns in an outfit.

Summer Time, 8" x 10",
ink and markers on
Bristol-weight paper

Punch up your art with vibrant color.

Combine color with black and white for dramatic effect.

Summer Time, 8" x 10", ink and markers on
Bristol-weight paper

Palazzo Pants

Palazzo pants can be fun or elegant, long and flowing or cropped—they make great shapes to tangle in! You can also experiment with pockets and waistbands.

1

I thought it would be fun to create different sizes of circles in these wide-leg palazzo pants. To keep my circles fairly uniform, I traced different sizes of coins, letting some circles overlap to add more texture and layers.

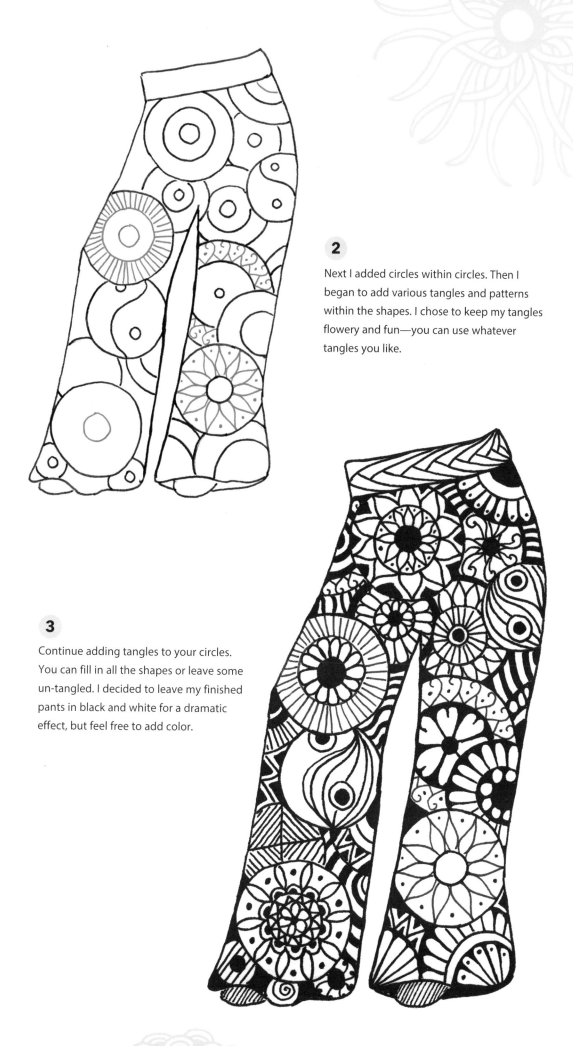

2

Next I added circles within circles. Then I began to add various tangles and patterns within the shapes. I chose to keep my tangles flowery and fun—you can use whatever tangles you like.

3

Continue adding tangles to your circles. You can fill in all the shapes or leave some un-tangled. I decided to leave my finished pants in black and white for a dramatic effect, but feel free to add color.

PRACTICE HERE

Draw your own tangled patterns in the palazzo pants on pages 50-52.

Inspired Design

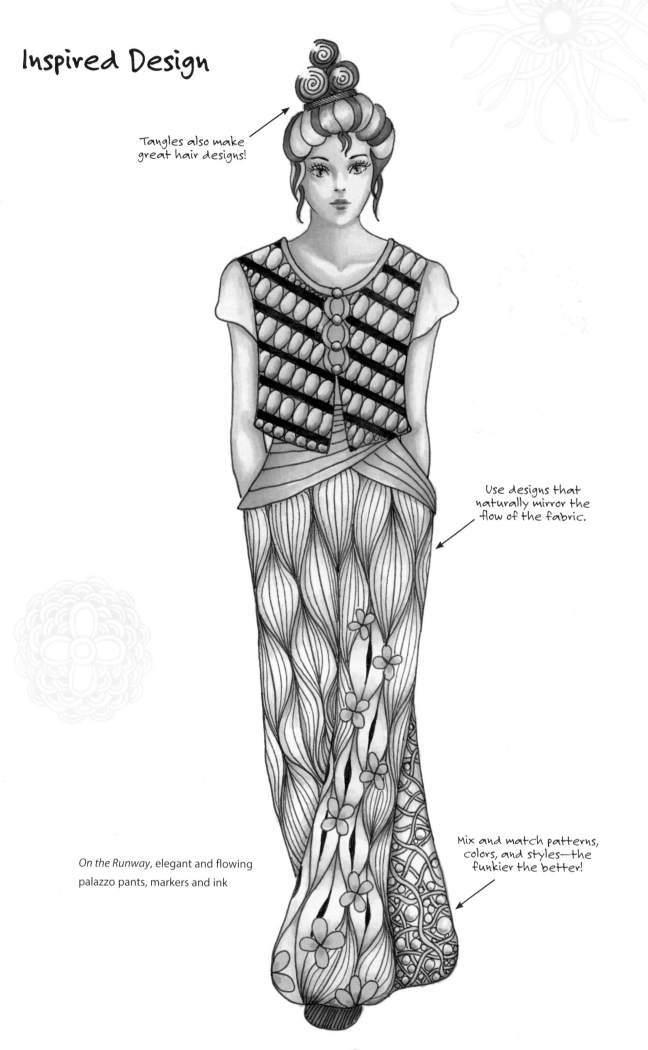

Tangles also make great hair designs!

Use designs that naturally mirror the flow of the fabric.

Mix and match patterns, colors, and styles—the funkier the better!

On the Runway, elegant and flowing palazzo pants, markers and ink

Tangled Paper Dolls

Who remembers playing with paper dolls? I sure do. I spent hours and hours playing with them as a little girl. Paper dolls are perfect for fashion tangling—you can create so many outfits! If you can wear it, you can tangle it. These outfits include a belly shirt with jeans, a t-shirt with a skirt and hat, and an off-the-shoulder dress.

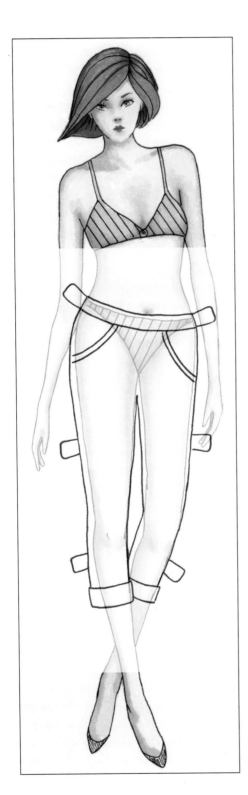

Use a light box to create the clothing piece by tracing over the doll's figure (see "How to Use a Light Box" on page 7). You can use the doll figure on page 56 as a model or create your own. Place a sheet of tracing paper over the doll. Draw a clothing outline around the doll's figure, leaving a little extra margin so the clothes cover the form (see example at left) and adding the tabs as you trace. To transfer the image, place a piece of graphite transfer paper face down on white card stock or a clean sheet of paper. Place the clothing outline on top of the graphite paper and trace over it.

Tip
I kept my doll fairly simple with clean lines and shorter hair so I can fit the tabs over her shoulders.

How to Use the Paper Doll Templates

Use the templates on pages 56–57 to start creating your own tangled paper dolls. You can photocopy the pages, or scan and print them from your computer (recommended). Feel free to use the templates as they appear or as inspiration to create your own. To use the doll figure and clothes as they appear, scan the artwork to your computer. Print the doll figure to size (use color ink) on heavy card stock; cut the figure out. Print the clothing templates to size (use black ink) on card stock or heavy printer paper. Tangle the clothes to your preference; then cut them out to style the doll.

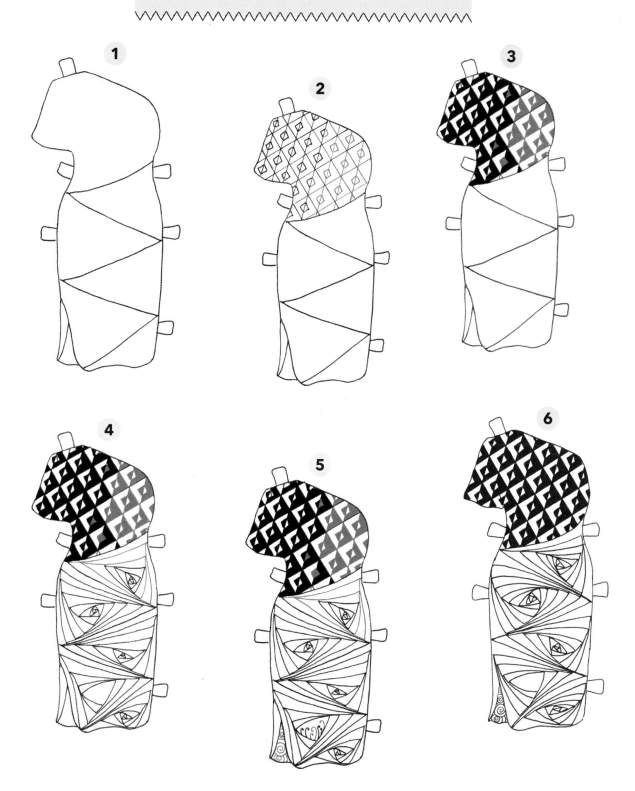

55

Paper Doll Templates

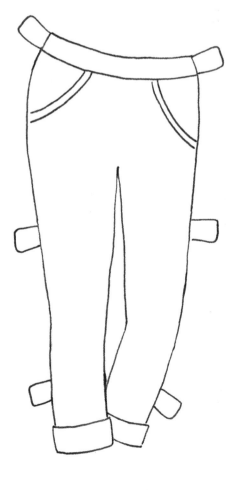

Inspired Designs

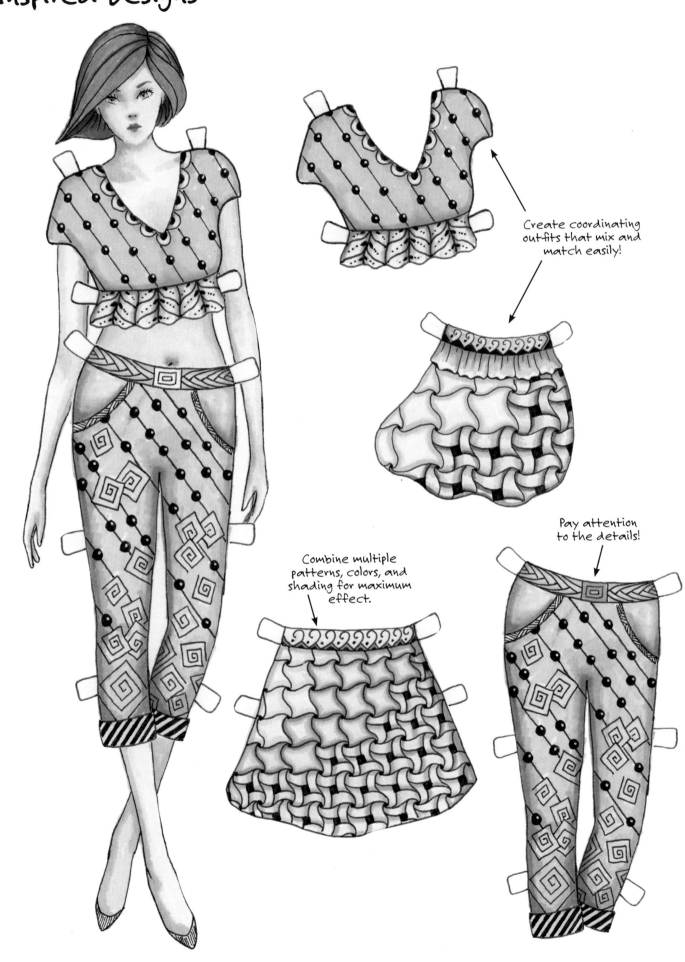

Create coordinating outfits that mix and match easily!

Combine multiple patterns, colors, and shading for maximum effect.

Pay attention to the details!

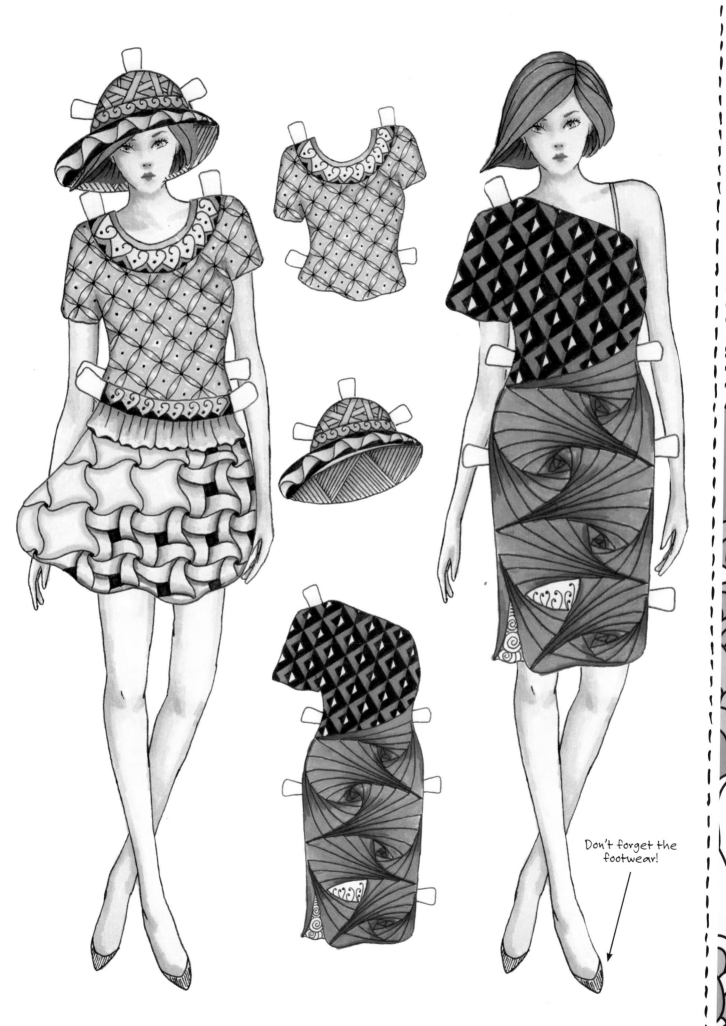

Don't forget the footwear!

Doodly Dresses with Heidi Cogdill

It's easy to create art every day—and you don't need tons of supplies to do it! Fashion tangling and doodling can be done on your couch, during your lunch hour, or even hanging out with your family. I started making what I call "Couture Tangles" a few years ago while watching The Oscars® and sketching some of my favorite gowns. Once the show started, I began to doodle inside one of my sketches. I loved the way the doodles filled the gown, and I've been drawing fashion doodles ever since. You never know when inspiration will strike, so keep an open mind and a pen or pencil at the ready!

Tips

• Flip through your favorite fashion magazines, or gather ideas from websites and blogs for inspiration and ideas.

• Incorporate whimsical elements into your designs, such as swirls, bows, hearts, or crisscross starbursts.

• Don't just doodle inside fashion forms; create the fashions themselves from doodles, patterns, tangles, and shapes.

Fashion-spiration!

Bold graphics, retro designs, and doodly flowers all lend themselves to whimsical fashions—especially when used to embellish ultra feminine pieces, such as ballerina tutus and fancy gowns. Combining simple doodles, such as hearts, dashes, dots, and lines, can also create an almost ethereal, wispy effect à la enchanted fairy tales; whereas blues, greens, and purples can further add to the dreamy effect. What patterns and colors inspire you? Sketch your ideas in the boxes below or attach favorite swatches and other images.

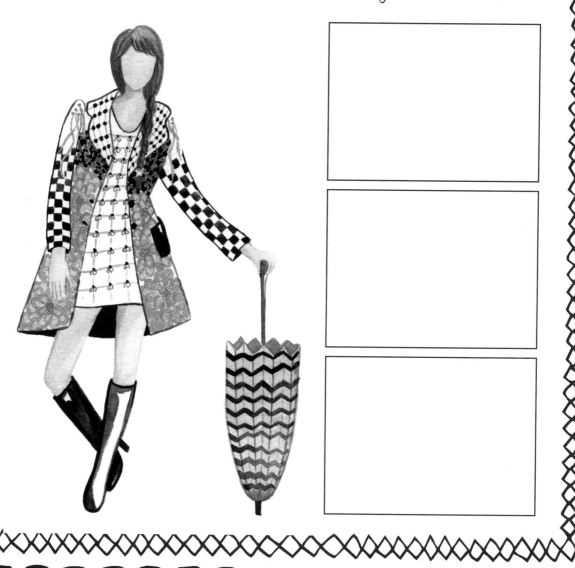

Sitting in Couture

My goal is always to create a drawing where the doodles blend effortlessly into the piece. In this flirtatious frock, it's all about the lines, which are elegant and flowy, rather than constrained to a structured outline. Because the upper body is prominent in the drawing, I kept my doodles to a minimum there to keep the focus on the skirt.

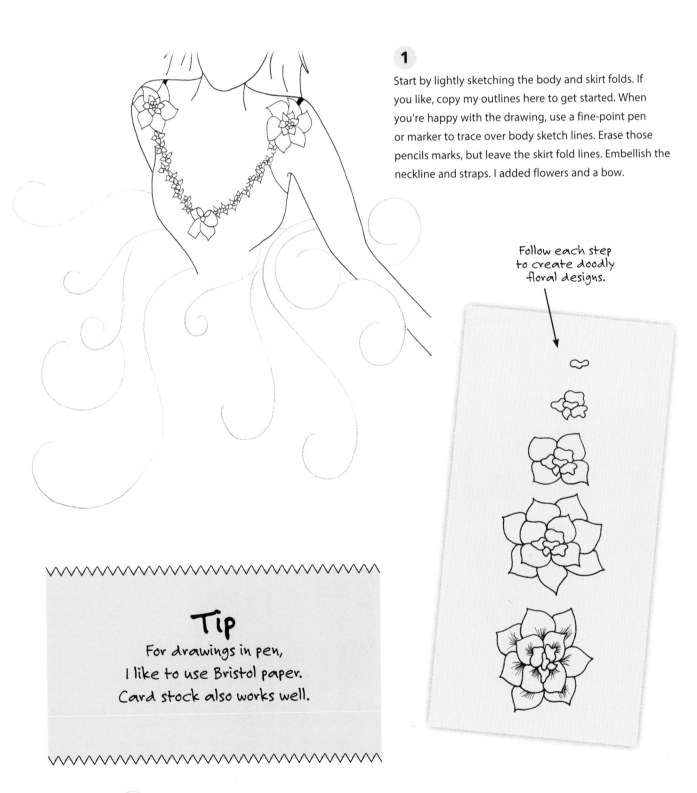

1

Start by lightly sketching the body and skirt folds. If you like, copy my outlines here to get started. When you're happy with the drawing, use a fine-point pen or marker to trace over body sketch lines. Erase those pencils marks, but leave the skirt fold lines. Embellish the neckline and straps. I added flowers and a bow.

Follow each step to create doodly floral designs.

Tip
For drawings in pen,
I like to use Bristol paper.
Card stock also works well.

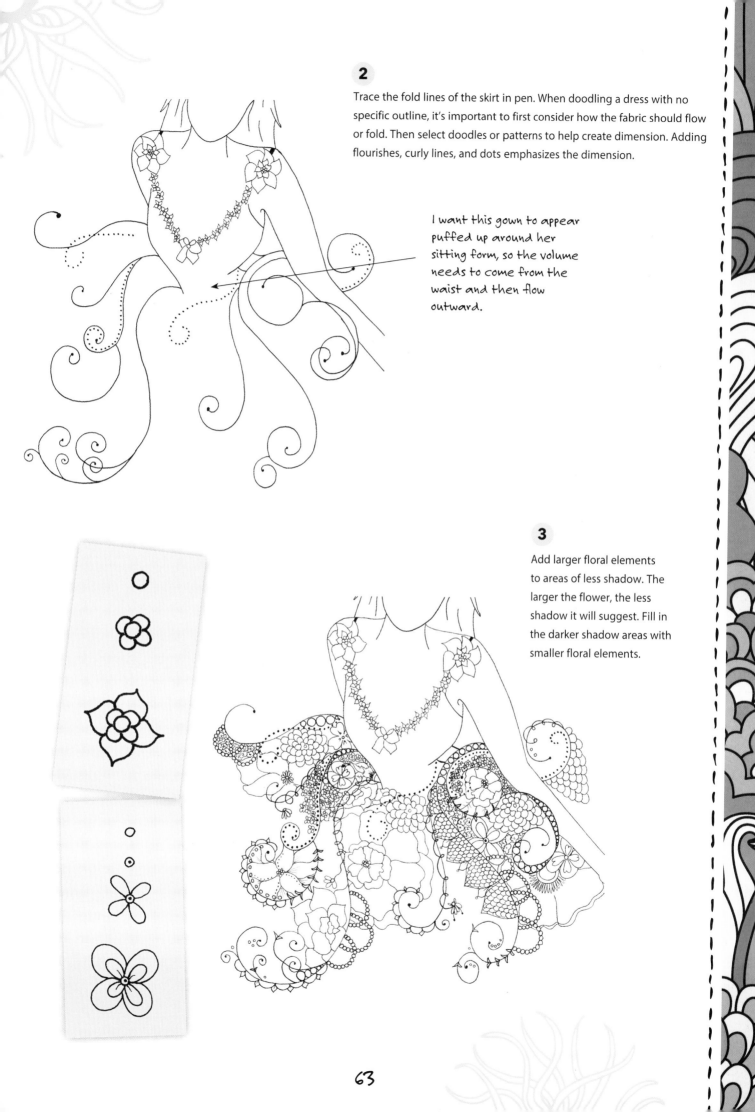

2

Trace the fold lines of the skirt in pen. When doodling a dress with no specific outline, it's important to first consider how the fabric should flow or fold. Then select doodles or patterns to help create dimension. Adding flourishes, curly lines, and dots emphasizes the dimension.

I want this gown to appear puffed up around her sitting form, so the volume needs to come from the waist and then flow outward.

3

Add larger floral elements to areas of less shadow. The larger the flower, the less shadow it will suggest. Fill in the darker shadow areas with smaller floral elements.

4

Look for areas that need darker lines to help define and add dimension to the skirt, and add fillers and enhancements to complete the gown. Finish by erasing any leftover pencil marks.

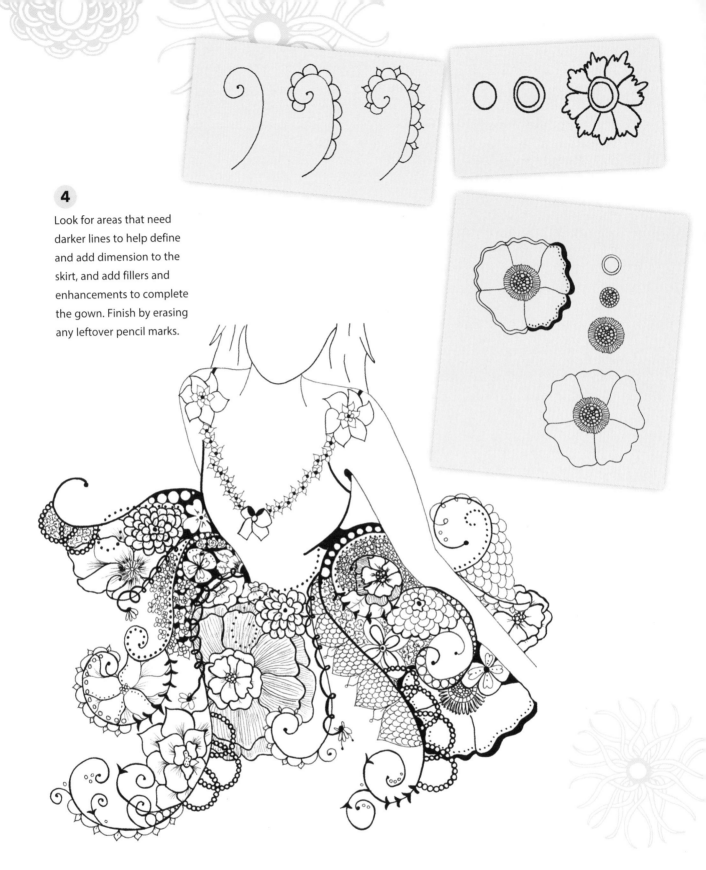

Tip

When drawing clothing, pay attention to the direction of the fabric. In this case, the fabric gathers and puffs out from the waist, and the weight of the fabric pulls it toward the floor. The deepest folds, and therefore darkest shadows, are closer to the waist.

PRACTICE HERE

Ballerina Tutu

There is something so graceful about a ballerina. I kept the doodles simple but playful to let the beauty of the figure shine through.

1

Start with a light sketch, and then outline with an archival ink pen. Erase the pencil marks when the ink is dry.

Follow each progressive step to draw the back laces.

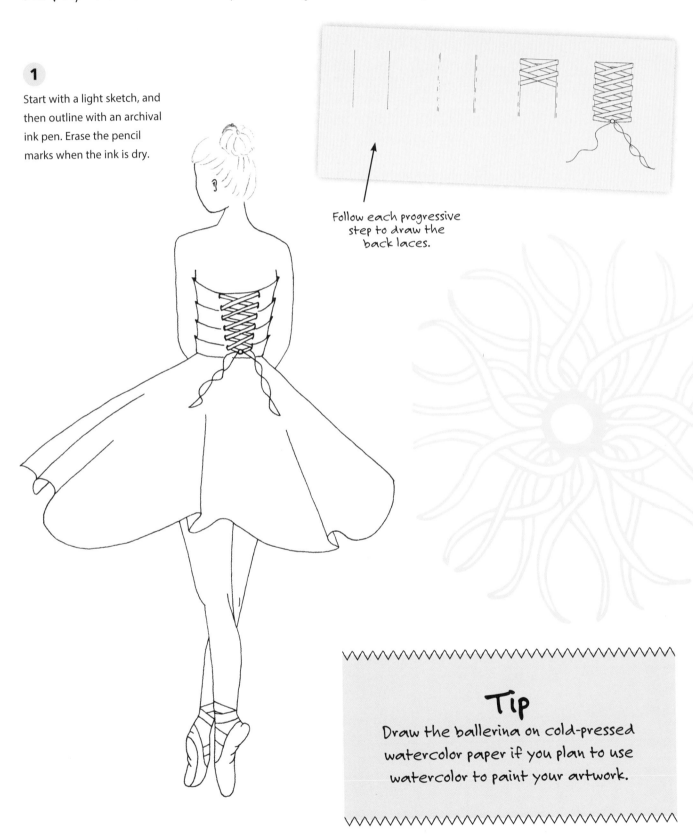

Tip

Draw the ballerina on cold-pressed watercolor paper if you plan to use watercolor to paint your artwork.

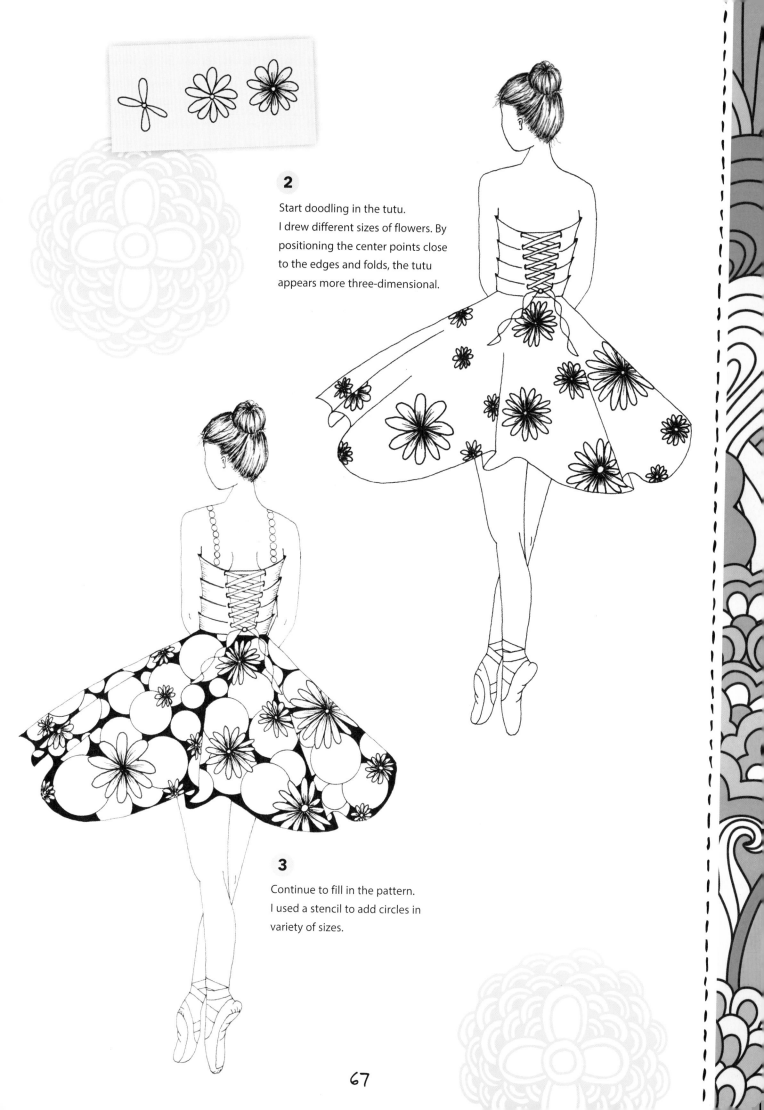

2

Start doodling in the tutu.
I drew different sizes of flowers. By
positioning the center points close
to the edges and folds, the tutu
appears more three-dimensional.

3

Continue to fill in the pattern.
I used a stencil to add circles in
variety of sizes.

4

Add color! I used watercolor paint, but you also can use colored pencils or markers—or even scan the art into your computer and color digitally.

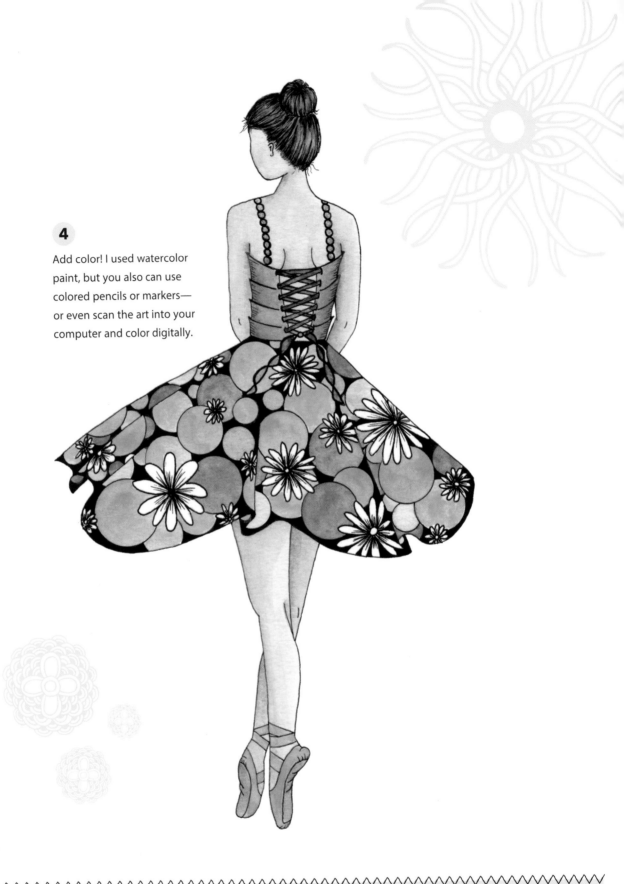

Tip

When drawing hair, always work from light to dark. Lightly outline the shape of the hair, and then go back and fill in the darker areas. Strokes should follow the direction of the hair.

PRACTICE HERE

Design your own doodled tutu below!

Bridal Gown

Bridal gowns offer a great canvas for doodle art and floral doodles are especially pretty. You can create elegant doodle patterns with just a few floral motifs. In this gown, I filled the entire dress with overlapping flowers.

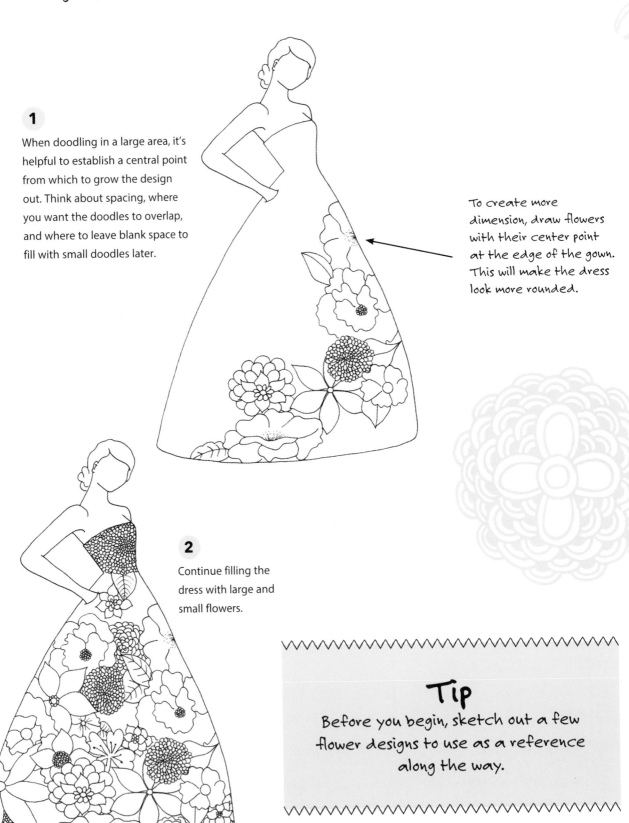

1

When doodling in a large area, it's helpful to establish a central point from which to grow the design out. Think about spacing, where you want the doodles to overlap, and where to leave blank space to fill with small doodles later.

To create more dimension, draw flowers with their center point at the edge of the gown. This will make the dress look more rounded.

2

Continue filling the dress with large and small flowers.

Tip
Before you begin, sketch out a few flower designs to use as a reference along the way.

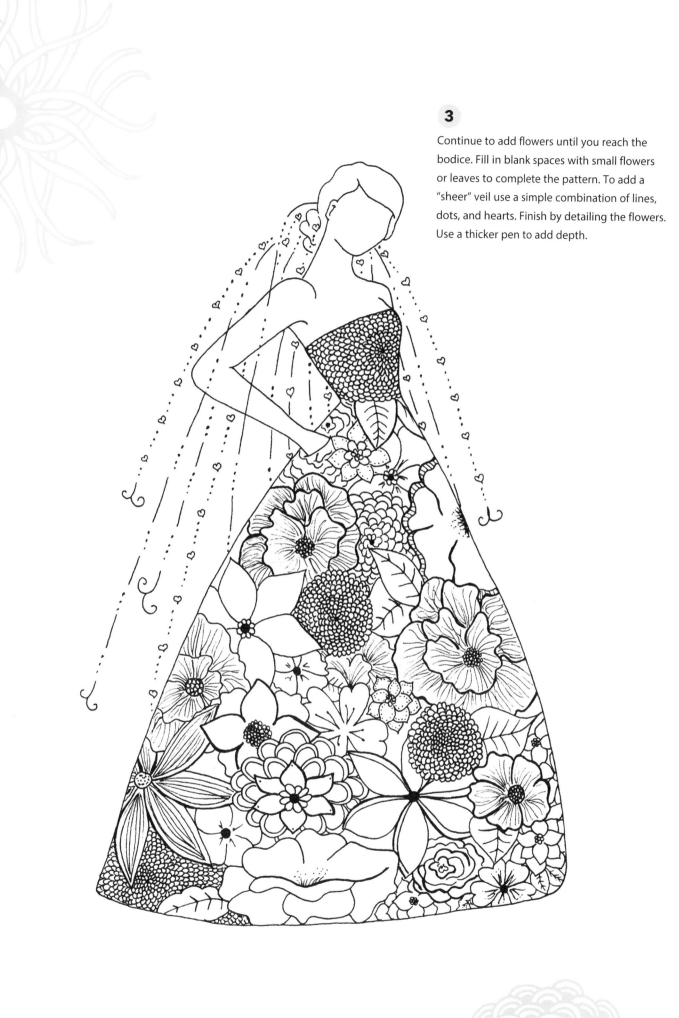

3

Continue to add flowers until you reach the bodice. Fill in blank spaces with small flowers or leaves to complete the pattern. To add a "sheer" veil use a simple combination of lines, dots, and hearts. Finish by detailing the flowers. Use a thicker pen to add depth.

Inspired Design

Tea Length

Modified A Line

Mermaid

Asymmetrical

Every bride needs a fabulous shoe for her big day!

Mini

Princess

When you're done with the dress, design a chic bridal clutch to go with it.

PRACTICE HERE

Fill this fabulous bridal gown with your doodles.
Turn to page 140 for more bridal gown templates.

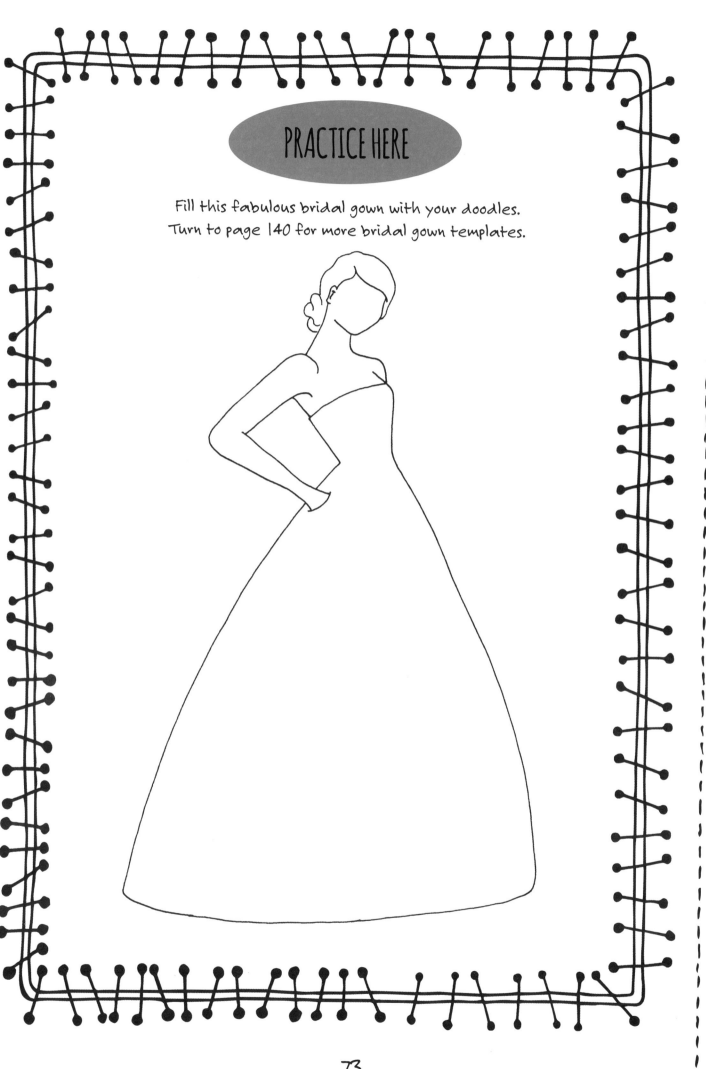

Enchanted Ball Gown

For this doodled ball gown, I chose a circle pattern and built each doodle with that in mind. Try your own doodle pattern with another shape if you wish.

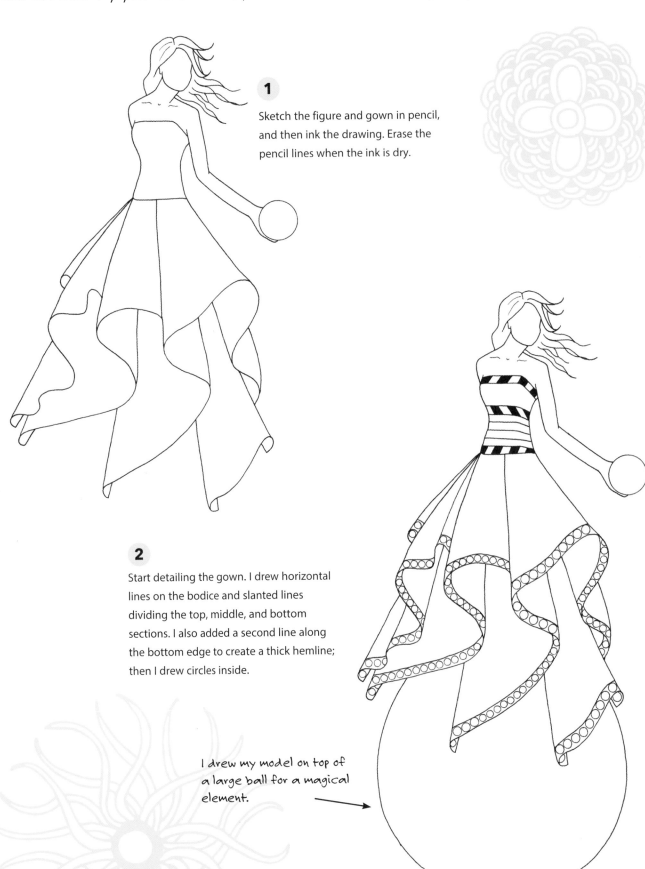

1 Sketch the figure and gown in pencil, and then ink the drawing. Erase the pencil lines when the ink is dry.

2 Start detailing the gown. I drew horizontal lines on the bodice and slanted lines dividing the top, middle, and bottom sections. I also added a second line along the bottom edge to create a thick hemline; then I drew circles inside.

I drew my model on top of a large ball for a magical element.

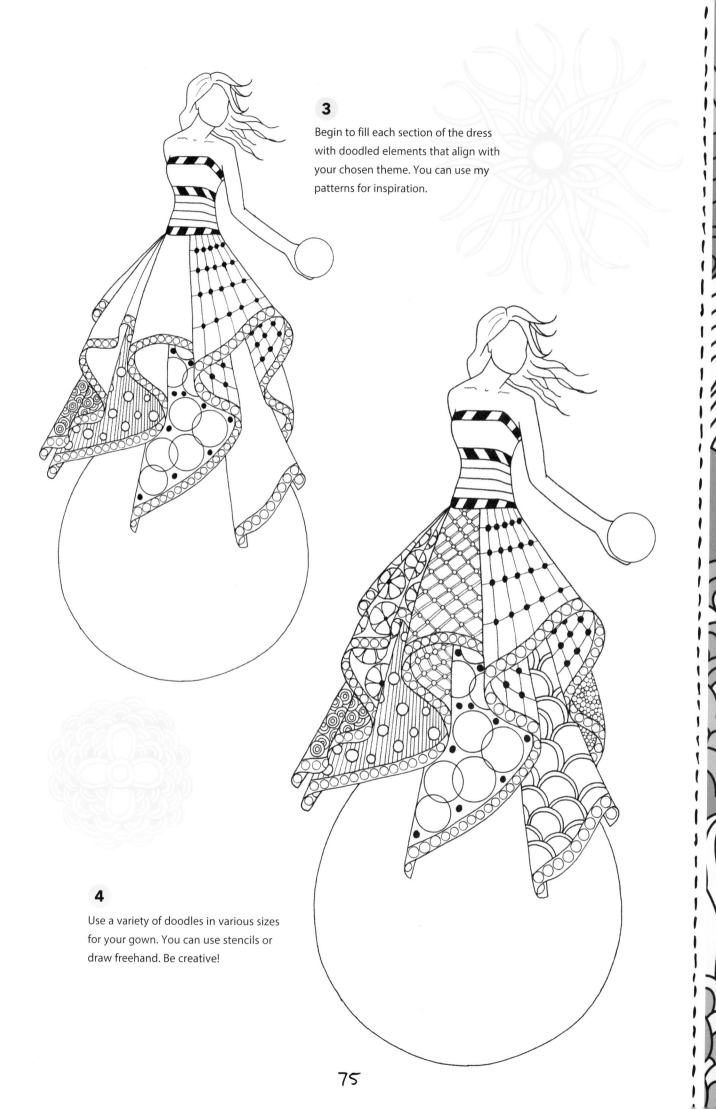

3

Begin to fill each section of the dress with doodled elements that align with your chosen theme. You can use my patterns for inspiration.

4

Use a variety of doodles in various sizes for your gown. You can use stencils or draw freehand. Be creative!

75

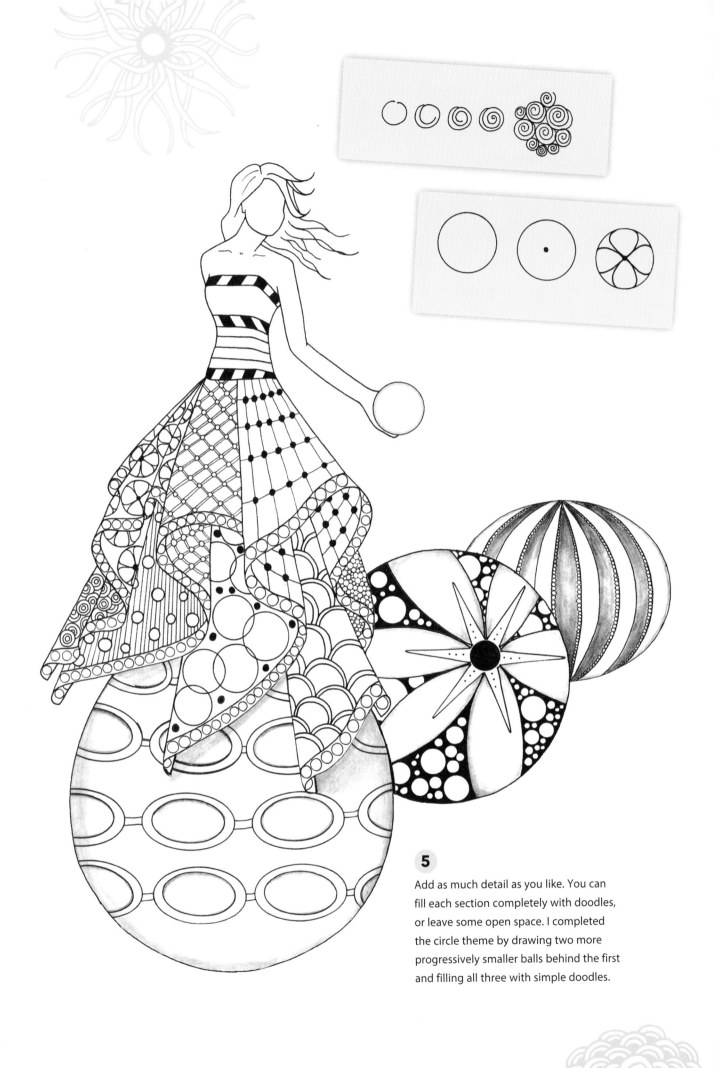

5

Add as much detail as you like. You can fill each section completely with doodles, or leave some open space. I completed the circle theme by drawing two more progressively smaller balls behind the first and filling all three with simple doodles.

PRACTICE HERE

Choose a shape or motif as a theme, and doodle your own enchanting gown here. How about using a triangle or diamond?

Mod Mini

Traditional doodle patterns can naturally lend themselves to a vintage vibe. This mod-mini look includes multiple garments, allowing you to blend numerous patterns.

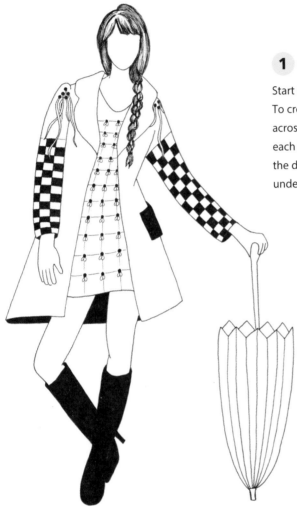

1

Start with a sketch of the figure, and fill in the hair. To create a similar look as mine, lightly draw a grid across the front of the mini dress. Draw a dot where each line intersects and two loops at the bottom of the dots. Use a thick marker to fill in the boots, the underside of the jacket, and the pocket.

2

Draw a repeating pattern on the front of the jacket.

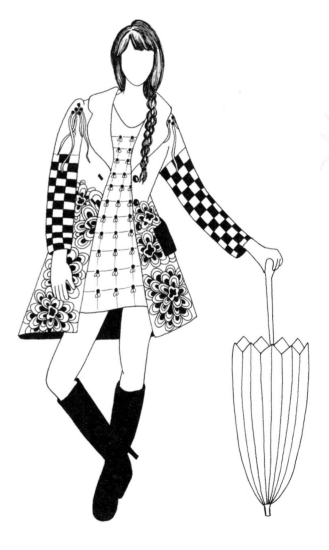

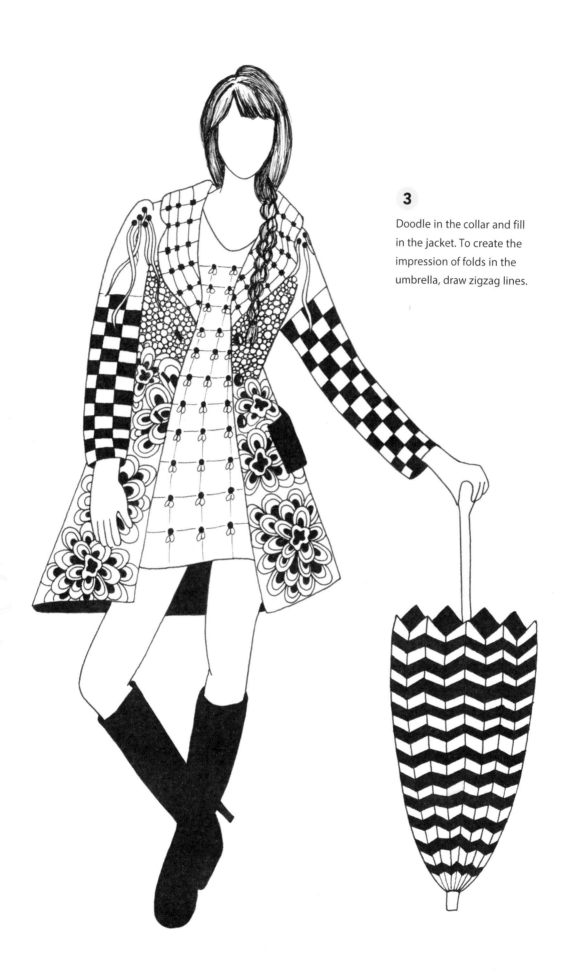

3

Doodle in the collar and fill in the jacket. To create the impression of folds in the umbrella, draw zigzag lines.

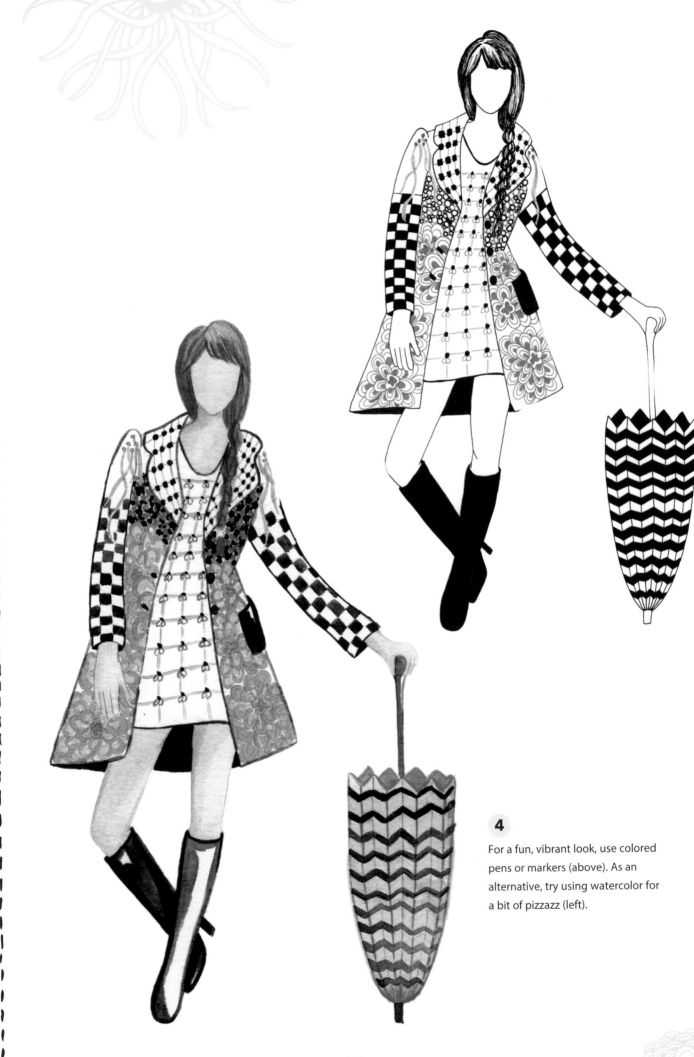

4

For a fun, vibrant look, use colored pens or markers (above). As an alternative, try using watercolor for a bit of pizzazz (left).

PRACTICE HERE

Design your own mod look below!

Fun Fashion Doodles with Jill Buckley

Doodling is a wonderfully spontaneous way to fill small moments of your day with creativity. During my days as a costume designer, doodling was a truly enjoyable part of my design process. Long after retirement, I still can't resist the call of my pencil and paper. At first glance, many of these drawings may appear complicated, but broken down into steps, you soon see that they are really nothing more than shapes filled with pattern. Embrace your inner artist, and unleash your doodling fashion creativity!

Tips

• Rulers and templates are helpful, but practice will help you learn to eyeball size and space, allowing for the wonderful freedom to draw anywhere with just paper and a pen.

• Experiment with shapes, patterns, and designs. Try "free" doodling to see where the art takes you!

• Play, play, play! Don't worry if your style differs from what you see around you. That's what makes fashion so fun—introducing fresh, new ideas that are uniquely yours!

Fashion-spiration!

When starting out in fashion-design drawing, it can be helpful to sketch around a mannequin or dress-form template. Just as real designers create outfits to fit a form, sketching around a mannequin can aid you in further working out your ideas, especially when you are still in brainstorming mode and want to get ideas on paper quickly. Mannequin outlines are also helpful for testing out pattern ideas to see how they work together before transferring the ideas to a garment. Use the blank template below to help work out your ideas.

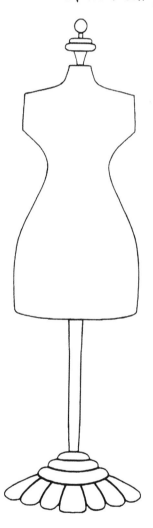

Alpha-Doodles

Doodling can be as simple as using marks you are already comfortable with—including the alphabet! While not every letter may be a great candidate, many lend themselves wonderfully to creating patterns. And, really, isn't that what a doodle is: a series of shapes filled with pattern?

Draw a "V" on its side, and slightly curve and extend the lines. Add a second, straight-lined "V" inverted in the center of the first; then embellish. This pattern adapts well to a variety of shaped segments.

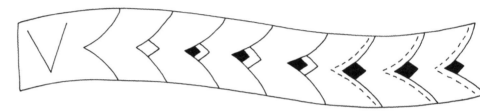

Practice here!

Draw the letter "C" in overlapping clusters. You can embellish with circles, dots, and lines.

Practice here!

Experiment with orientation, as I did with a lowercase "I." Flip the letters, mirror them, and place them upside down and sideways.

Practice here!

84

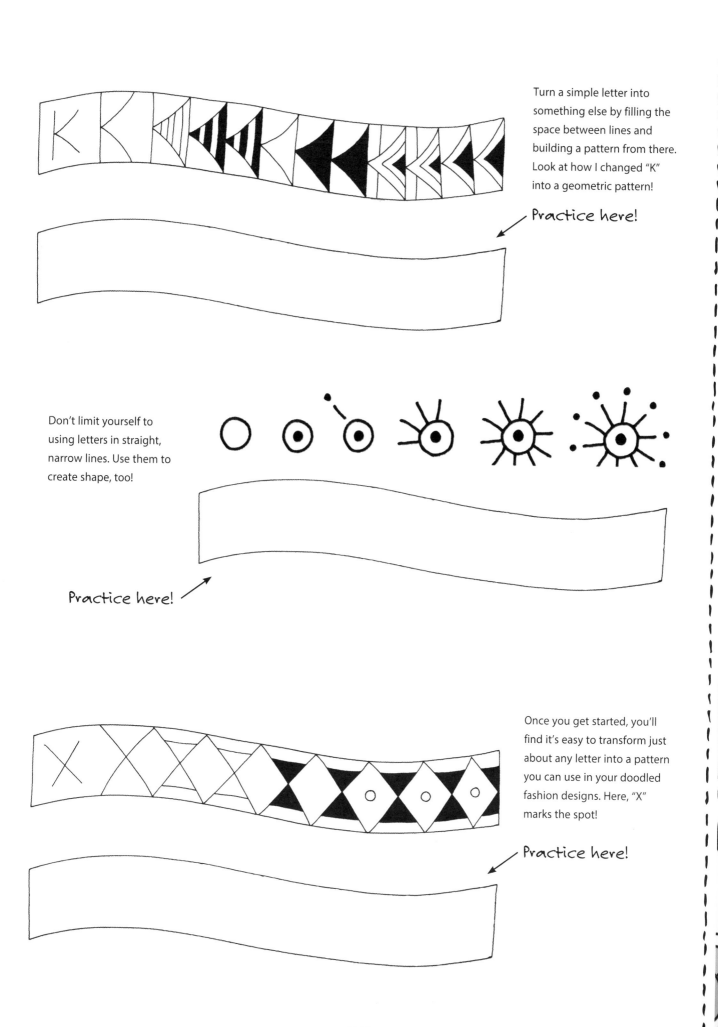

Turn a simple letter into something else by filling the space between lines and building a pattern from there. Look at how I changed "K" into a geometric pattern!

Practice here!

Don't limit yourself to using letters in straight, narrow lines. Use them to create shape, too!

Practice here!

Once you get started, you'll find it's easy to transform just about any letter into a pattern you can use in your doodled fashion designs. Here, "X" marks the spot!

Practice here!

Alpha-Doodle Corset

Take a close look at my finished corset on page 88. Would you immediately recognize that the patterns in the design all originate from the simple use of letters? Check out my examples, and then allow yourself play as you create your own. Your doodles will differ from mine...just like a signature, yours will be unique to you!

1

Draw a corset outline, adding areas in which to build your design, or trace this corset at right to use as your template, if desired.

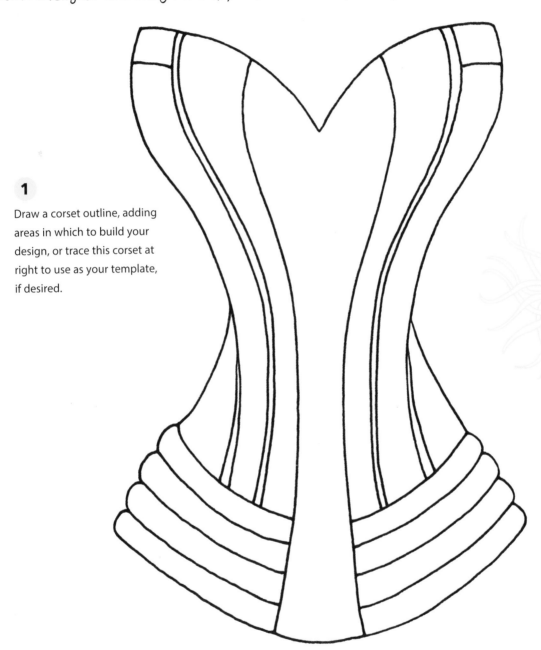

Tip

The orientation of your letters may be most effective sideways or upside-down. Rotate your work so that the letter placement feels natural for you to write.

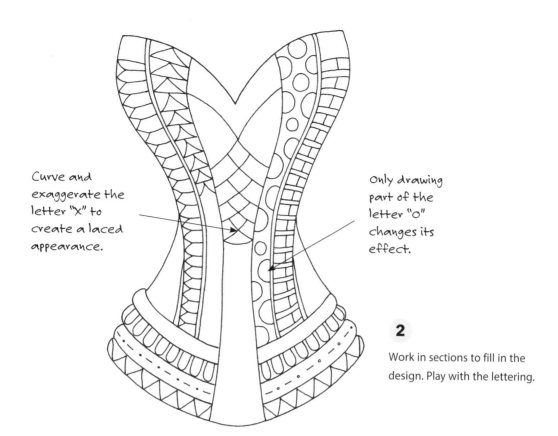

Curve and exaggerate the letter "x" to create a laced appearance.

Only drawing part of the letter "o" changes its effect.

2

Work in sections to fill in the design. Play with the lettering.

3

As you fill each section with various lettering, you begin to see the patterns take shape. With the initial pattern filled in, look for areas to embellish with lines and dots.

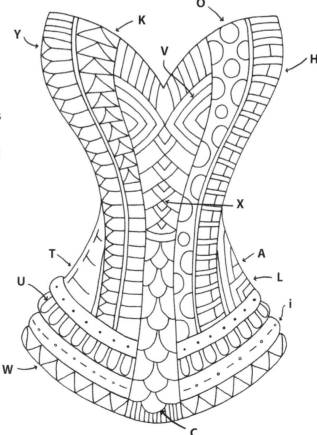

4

Add extra details and fill in
some areas to dramatically
alter the look of the
finished design.

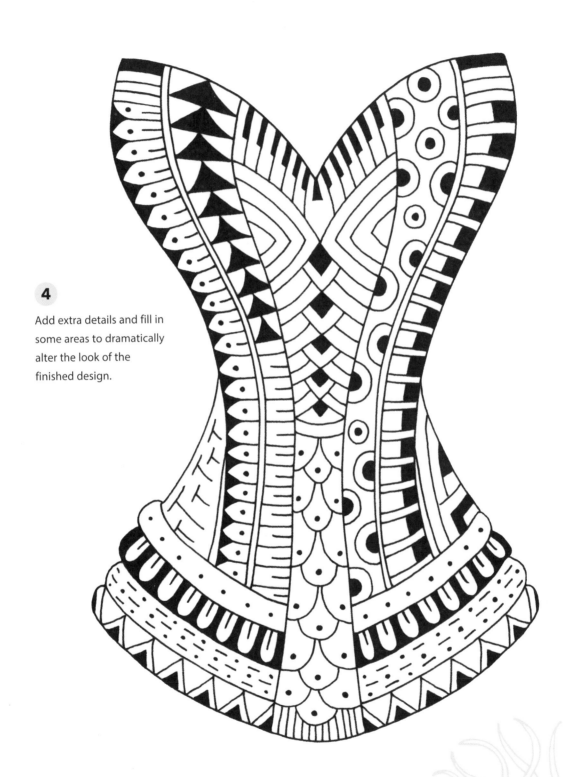

Necklines & Yokes

Scoop-neck shapes and yokes are perfect for experimenting with pattern. Try the Alpha-Doodle technique (as seen on the mannequin) or experiment creating your own designs.

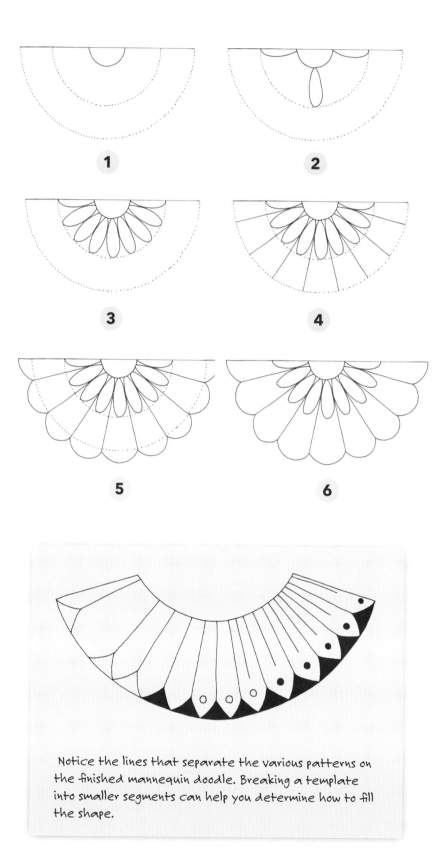

1

2

3

4

5

6

Notice the lines that separate the various patterns on the finished mannequin doodle. Breaking a template into smaller segments can help you determine how to fill the shape.

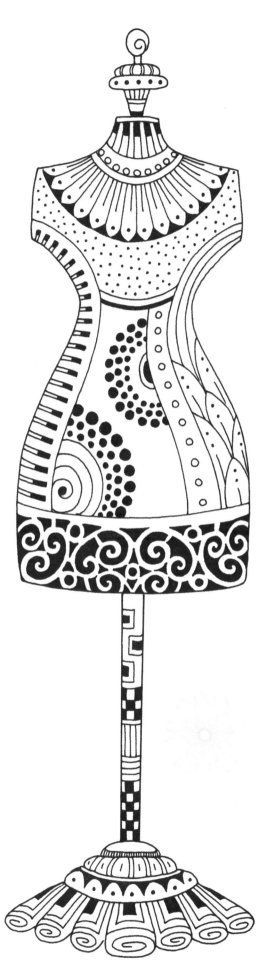

Tangled Hats

For these tangled hats, focus less on building individual patterns and more on creating interesting elements. A close inspection of this hat reveals that it is not a hat at all; it's a variety of fun, easy-to-draw bits and pieces!

Start with a few of the designs on the opposite page; then try creating some of your own. By following the progression of each element, you can see how simple each pattern is.

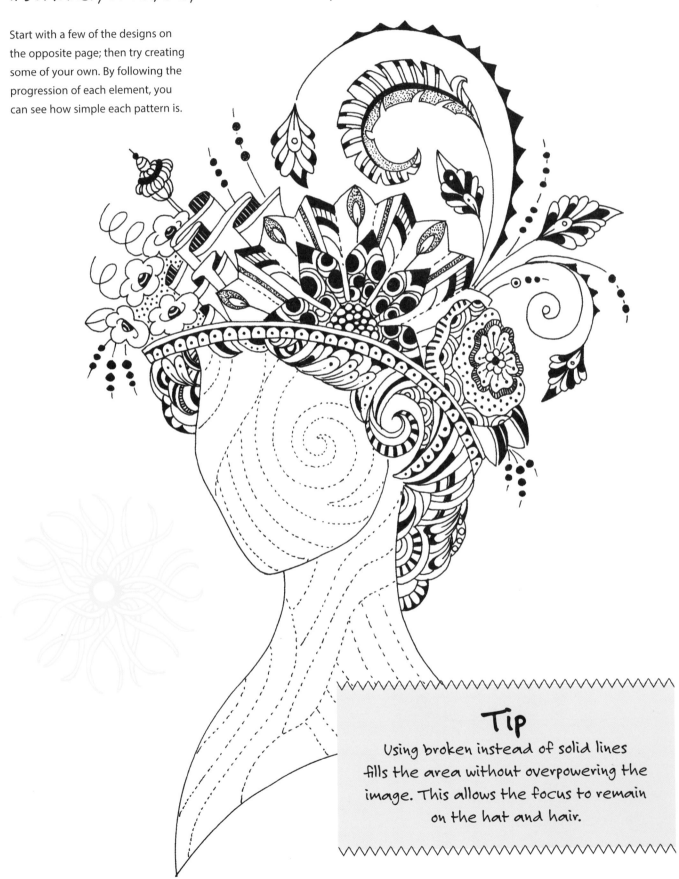

Tip
Using broken instead of solid lines fills the area without overpowering the image. This allows the focus to remain on the hat and hair.

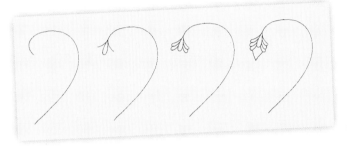

These flowers are nothing more than a series of "C" shapes grouped together.
Make one or clusters of them, and vary the size and angle.

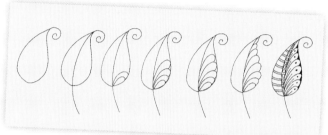

Add height with some tall elements, such as this
curved feather. You can add a few or fill the hat
with feathers. Consider adding shapes to the spine for
extra interest.

This paisley-shaped feather would make a great
addition to any doodled hat!

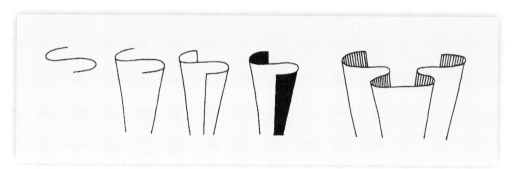

Add drama and movement with a ruffled ribbon. Define the front and back by
treating the areas differently. Closely placed stripes, stippling, shading, and filling
in are all great options.

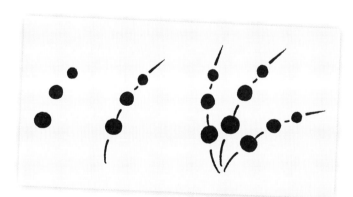

Create easy fillers with dots and dashes placed in
singles or clusters.

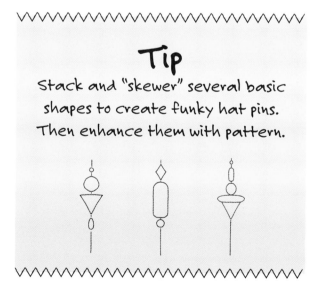

Tip
Stack and "skewer" several basic
shapes to create funky hat pins.
Then enhance them with pattern.

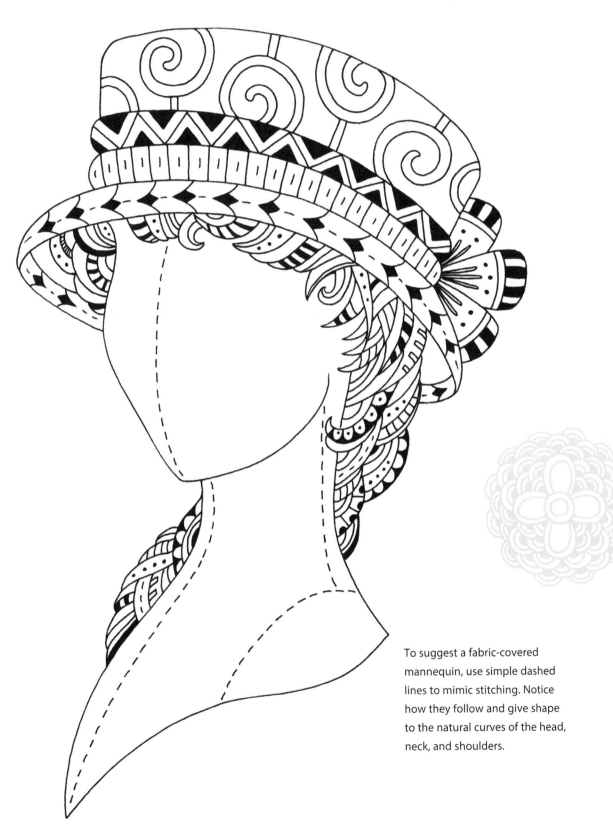

To suggest a fabric-covered mannequin, use simple dashed lines to mimic stitching. Notice how they follow and give shape to the natural curves of the head, neck, and shoulders.

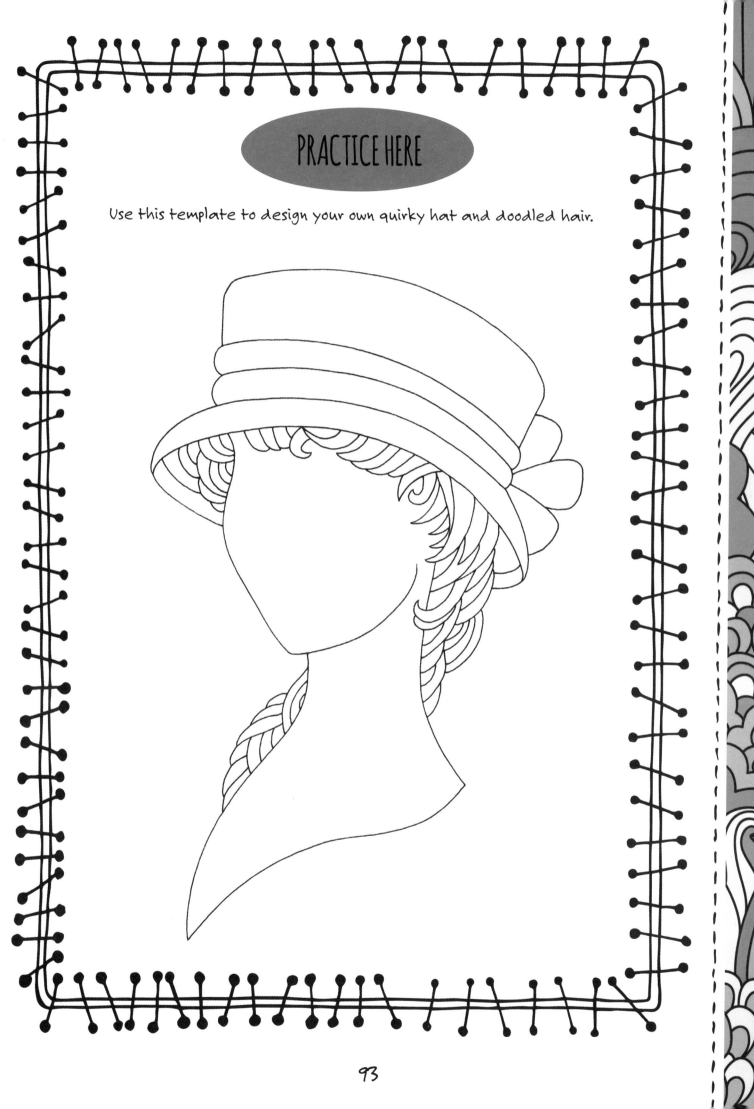

PRACTICE HERE

Use this template to design your own quirky hat and doodled hair.

Shoes & Boots

Wouldn't you love to design your own shoes and boots? Where would you start? The prompts and ideas here will help inspire you!

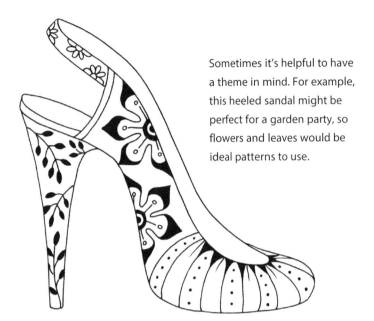

Sometimes it's helpful to have a theme in mind. For example, this heeled sandal might be perfect for a garden party, so flowers and leaves would be ideal patterns to use.

Graphic Pattern

Draw some randomly placed circles, with a few cut off. Draw and fill in smaller circles inside. Fill the negative space around the large circles with tiny dots. Try this technique with squares, triangles, diamonds, etc.

Try playing with simple graphics—stripes, checks, circles, dots, and dashes. Maybe even a little alpha-doodle. It's also fun to consider how your subject might look from a different angle.

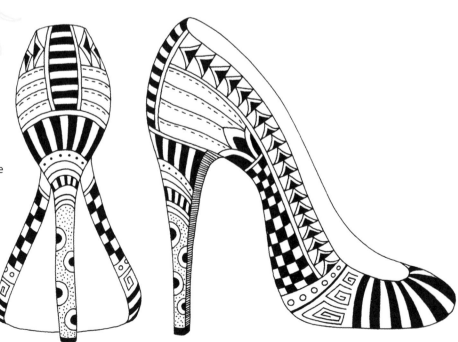

Reptile Pattern

1

Lightly draw wavy, parallel guidelines from edge to edge as shown. (These lines will be erased in the final stage.)

2

Between each of the parallel lines, draw rounded rectangular shapes.

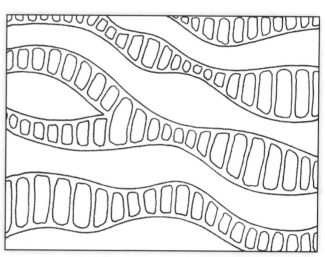

3

Continue drawing shapes until the area is filled.

4

Erase the guidelines.

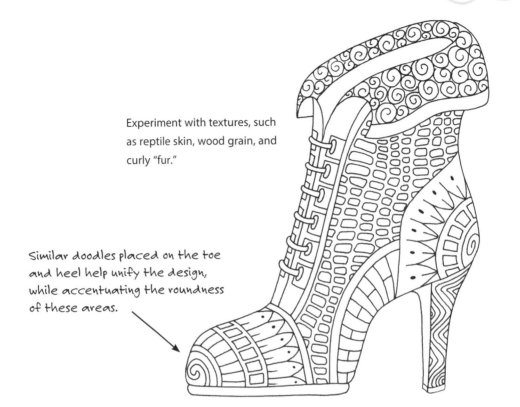

Experiment with textures, such as reptile skin, wood grain, and curly "fur."

Similar doodles placed on the toe and heel help unify the design, while accentuating the roundness of these areas.

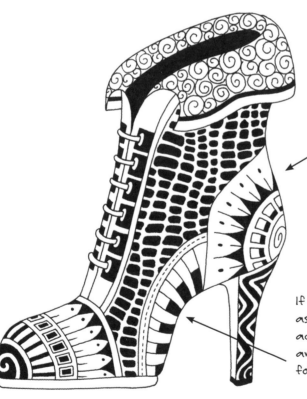

Play with the effects of positive and negative space (light and dark) to dramatically change the look of your drawing.

If you're working in a curved area, such as the toe and arch, draw your lines accordingly. Notice how the line in the boot's arch gradually changes direction as it follows the curve of the foot.

PRACTICE HERE

Use these templates to play with your ideas!

Handbag

Now let's turn our attention to doodling some little handbags, from fancy clutches to simple coin purses. Obviously the bag itself offers a nice space for doodling and tangling, but don't forget about the hardware.

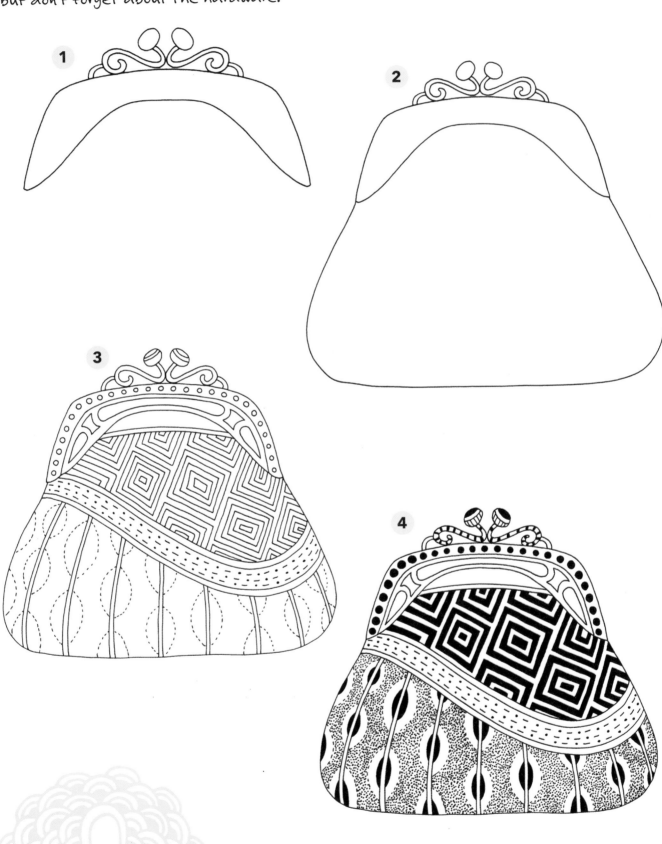

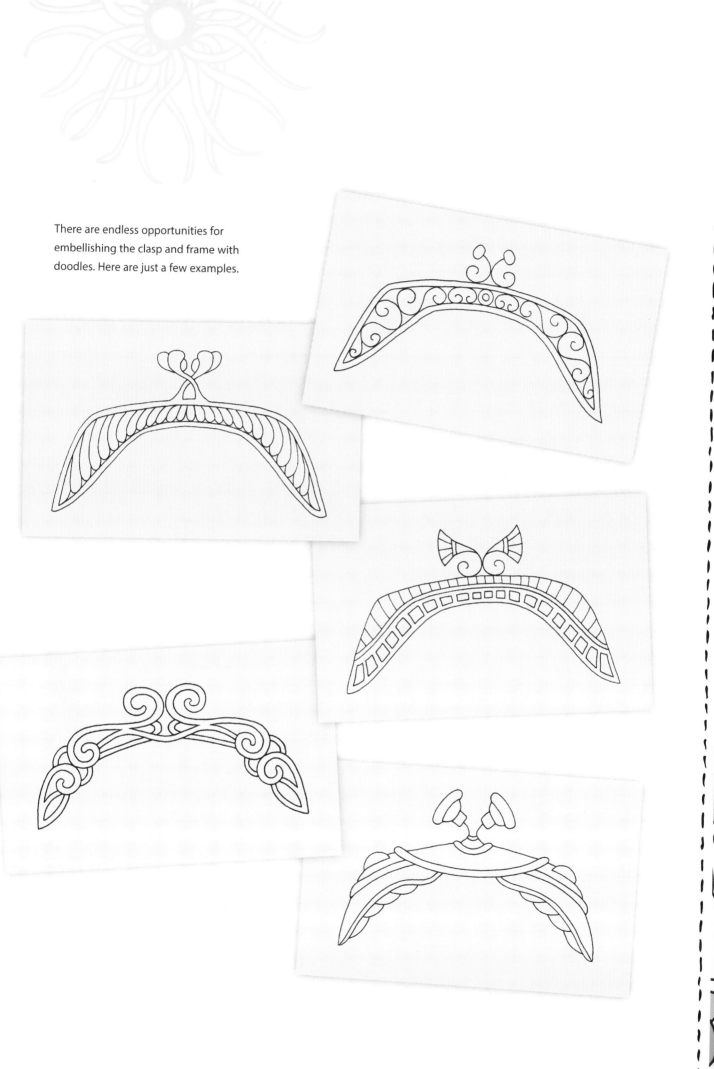

There are endless opportunities for embellishing the clasp and frame with doodles. Here are just a few examples.

1 Patterns that repeatedly "echo" a shape add tremendous interest to any design. They are versatile, easy to create, and work in any space. Study the progression of this example, and then try your own.

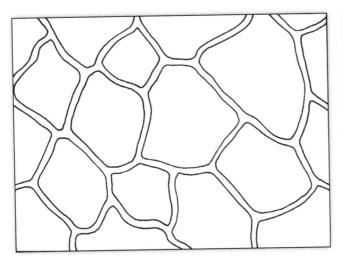
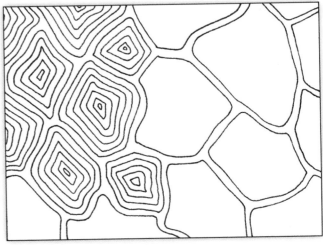

2 Draw shapes evenly spaced apart. Using the first few shapes as a guide, continue to place more shapes, allowing some of them to drift off the edge. Strive to keep the distance between each shape fairly even.

3 Continue until the entire area is filled with shapes; then add patterns. I used echo lines.

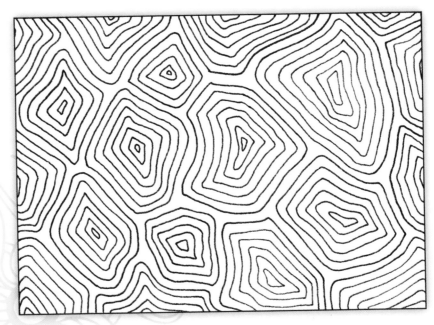

4

Complete the design and add color if you like!

Echo Design
Variation

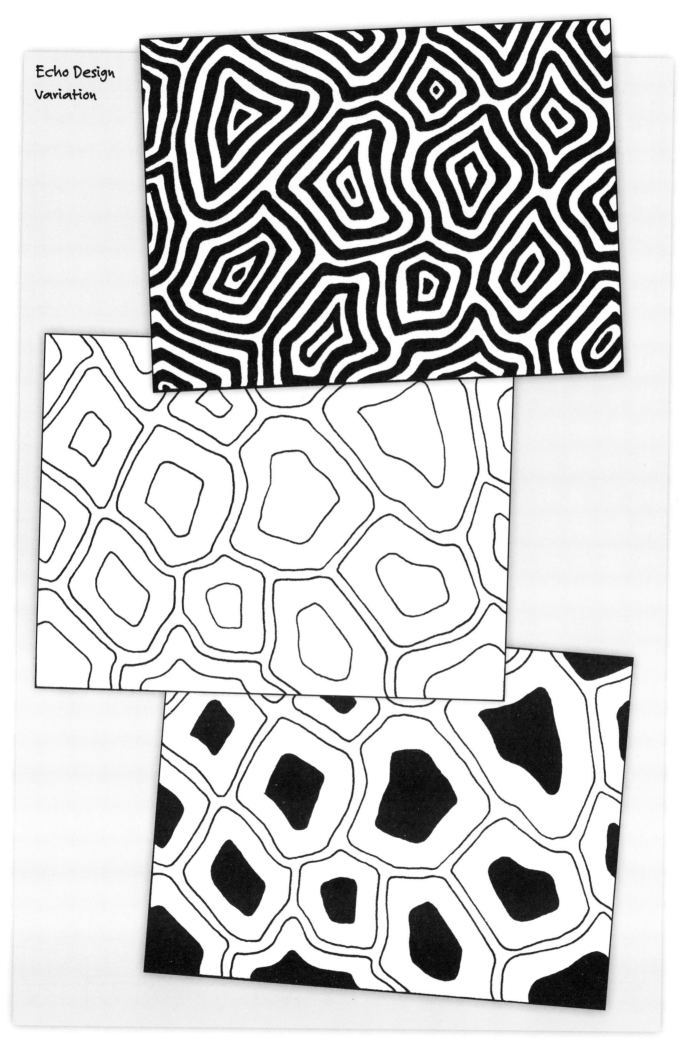

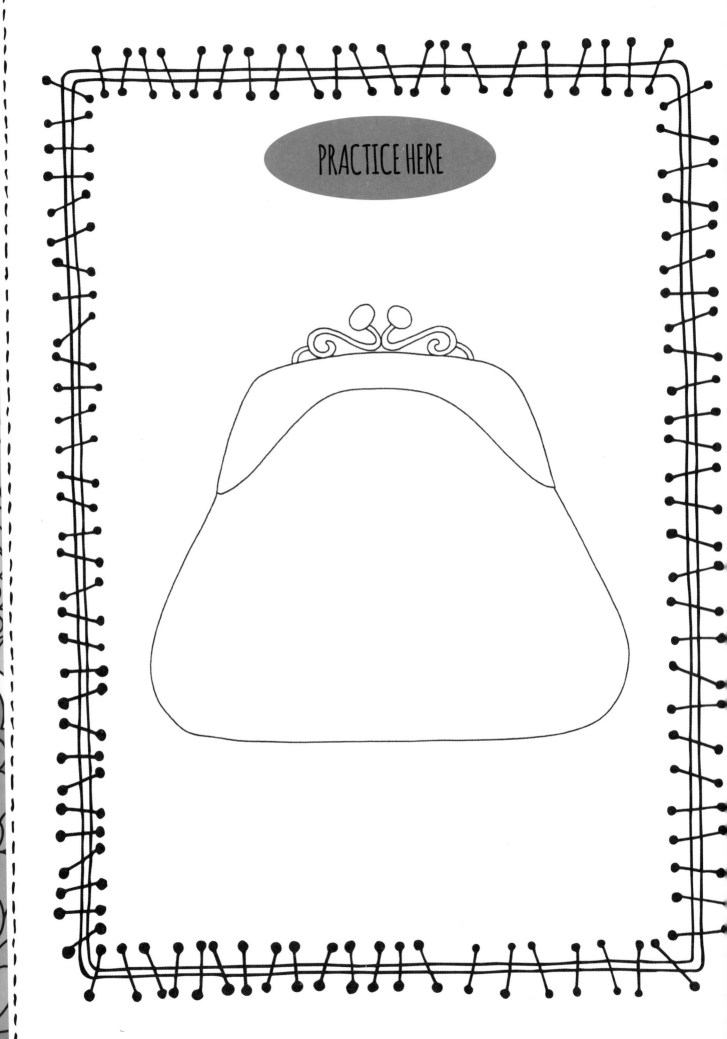

PRACTICE HERE

PRACTICE HERE

Wild Hair with Jody Pham

Hairstyles are a fun and inventive way to create doodles and tangles. The fashion world embraces the unexpected, so whether you prefer traditional styles or avant-garde, the sky is the limit! Start with a basic face, and adorn with a mixture of your favorite patterns to build unique hairstyles. Then add a variety of wild and eclectic accessories.

Tips

• If you make a mistake, don't fret! The best thing about tangle art is there is no such thing as a mistake. You can transform any unintended line into something else, and no one will ever know!

• A size 05 pen is perfect for details, such as eyelashes, while a larger size, such as 08, works great for filling in or outlining larger areas.

Fashion-spiration!

Look at the image below. What do you see? Flowers, trees, branches, vines, peacock feathers, perhaps even a highway or a billion planets and stars? When you allow yourself to see art in new and different ways, there are no limits to what you can create! What if her hair were made entirely of words from your favorite book or the lyrics of a special song? What if you filled it with symbols or drawings that represent the best day of your life? Allow your imagination to stretch its wings and fly you to the far reaches of the Universe. You never know where inspiration is to be found!

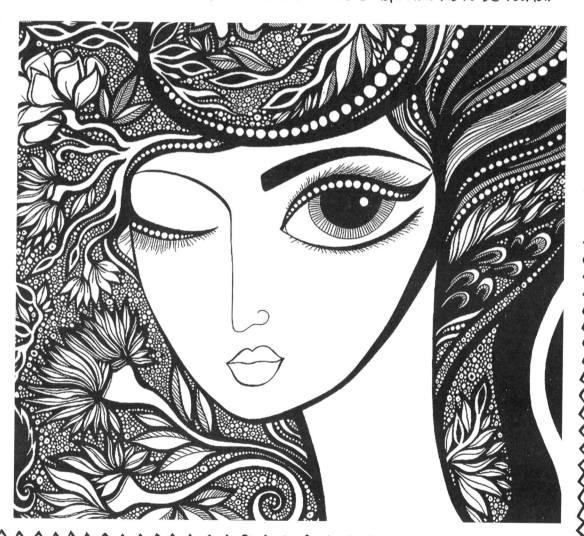

Fashion Statement Hair & Necklace

This project is the perfect way to combine bold lines, patterns, and one of my favorite fashion accessories: the statement necklace! Creating a hairstyle that utilizes some of the same patterns is a great way to create a cohesive piece with lots of visual interest.

1

Use a pencil to lightly sketch the face; then ink over the lines. Create an abstract base for your tangled hairstyle by sketching curved, oblong circular shapes.

2

Begin filling the hair with pattern. I added a series of leaves across the curve of the forehead and some larger leaves at the base of the lower cheek to act as an anchor around which to build my tangles.

3

Build out the design with clusters of droplets to frame the leaves. Add tangled strands of "hair" flowing in different directions to create a sense of movement. Darken alternate strands to create lovely contrast.

4

Fill in the hair with small circles of various sizes. Begin tangling a cascading, loose braid pattern that follows the shape of the swirls.

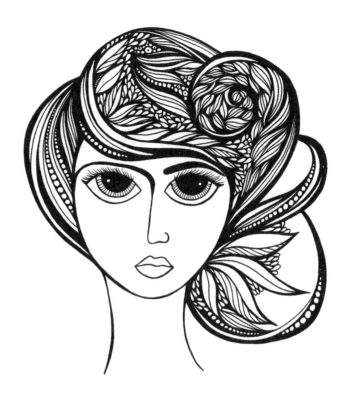

5

Finish filling in the hair; then outline the statement necklace. I drew a half-circle and added diagonal lines to divide it into five sections. Make the outside of the necklace bolder to create contrast with the patterns inside.

I added a series of small circles to the top band of the necklace.

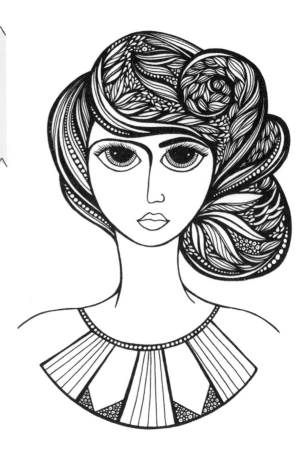

Tip

Any consistent pattern will work for this necklace. Use your imagination!

6

To create this pattern, start by drawing two diagonal lines in the second and fourth sections to create points. Fill the space on either side with circles of different sizes. Draw even, vertical lines in the remaining necklace sections.

7

Create fun dimension by using alternating diagonal lines to fill in the vertical lines. Fill the rest of the sections with a blend of your favorite tangle patterns. I used contrasting scales, circles, and leaves. You can also sketch your tangles in pencil before inking if you prefer. Just erase any leftover pencil marks when the ink is dry!

Tip

Gel and glitter pens are perfect for adding a touch of sparkle to your statement necklace.

PRACTICE HERE

Fill this piece with your own
tangled hair and statement necklace!

Feather & Rhinestone Fascinator

Hair fascinators have been a staple in the world of fashion for decades, and I adore the way they add a sense of old-world glamour to any ensemble. They make the perfect accompaniment to the unique patterns and unexpected flair of tangles!

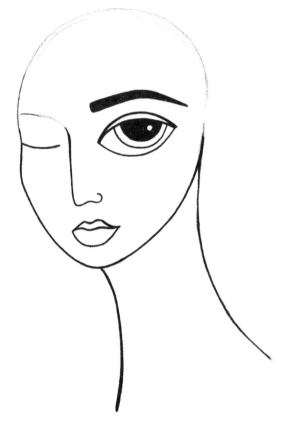

1

Lightly sketch a face in pencil. I opted to make one eye winking, but you can keep both open if you prefer. Trace the lines in pen, but stop your outline just above the cheekbones to leave room for the hair to fall.

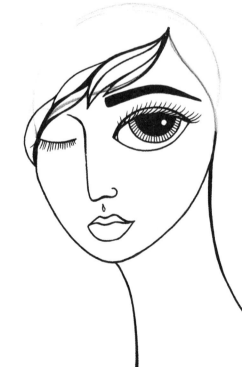

2

Add small details, such as eyelashes. Then create a starting point for the hair by drawing a swooping line across the forehead and one side of the face. Begin to draw leaf-shaped tendrils along the forehead.

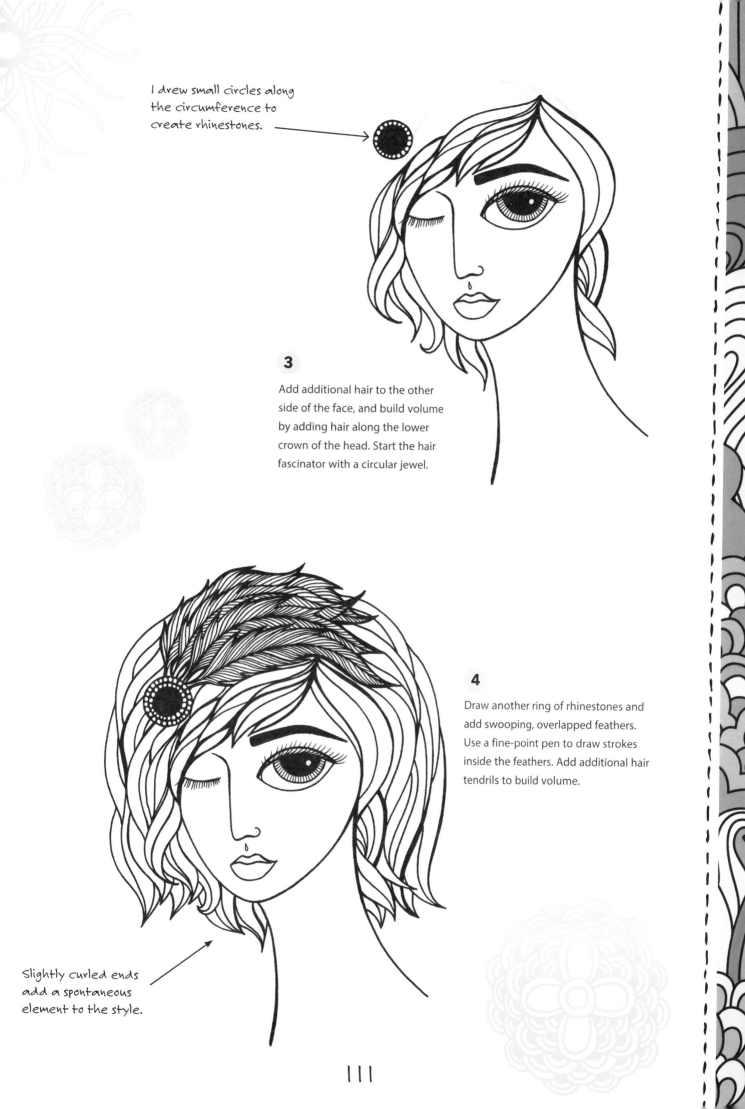

I drew small circles along the circumference to create rhinestones.

3

Add additional hair to the other side of the face, and build volume by adding hair along the lower crown of the head. Start the hair fascinator with a circular jewel.

4

Draw another ring of rhinestones and add swooping, overlapped feathers. Use a fine-point pen to draw strokes inside the feathers. Add additional hair tendrils to build volume.

Slightly curled ends add a spontaneous element to the style.

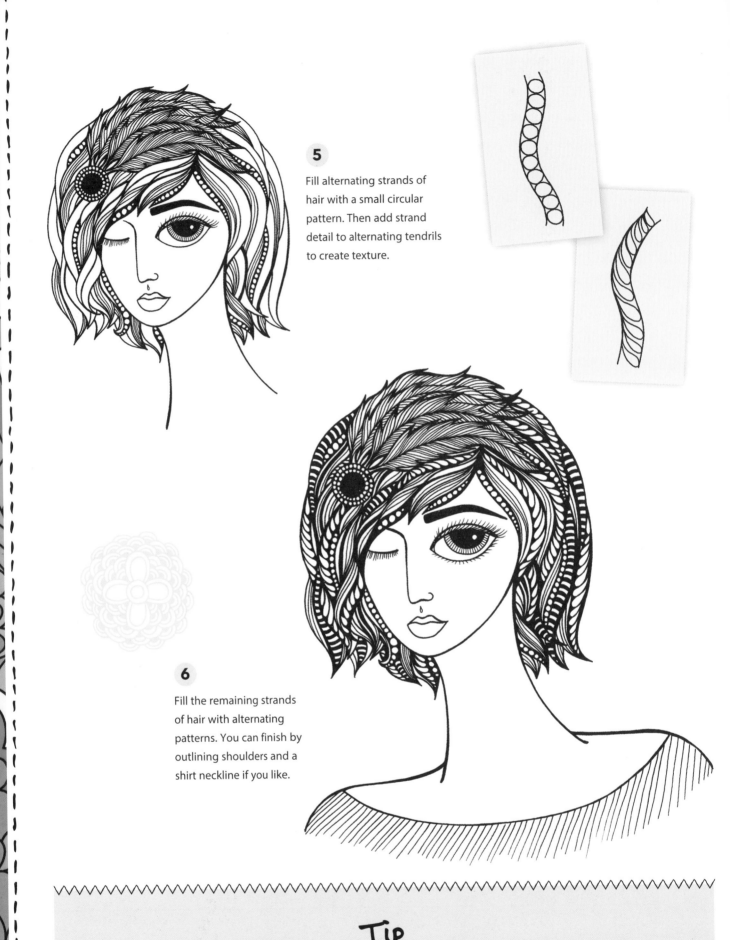

5

Fill alternating strands of hair with a small circular pattern. Then add strand detail to alternating tendrils to create texture.

6

Fill the remaining strands of hair with alternating patterns. You can finish by outlining shoulders and a shirt neckline if you like.

Tip
Use bold color to fill in the hair, leaving the fascinator in black and white.
The effect is stunning!

PRACTICE HERE

Design your own flirtatious fascinator here.

Wild Hair Gallery

As you can see from these wild hairstyles, each look is distinctive, despite having the exact same face!

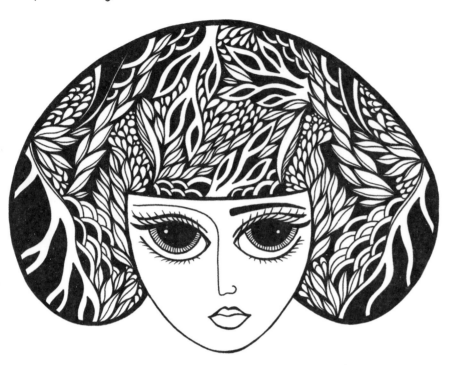

An alternate way to tangle hair is to begin with an outline first, and then fill it with assorted flora and patterns. Fill in the space behind the floral outlines to make your designs "pop."

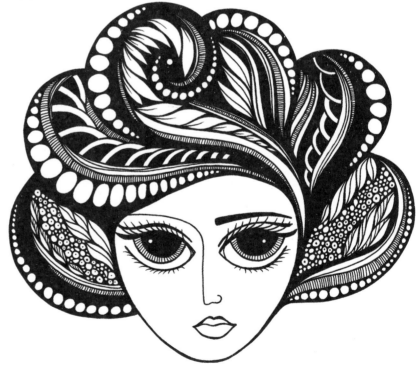

I drew inspiration from one of my favorite ocean creatures, the octopus, for the shape and movement of this style. One of the best things about tangling is that you can incorporate seemingly unrelated elements into a cohesive design.

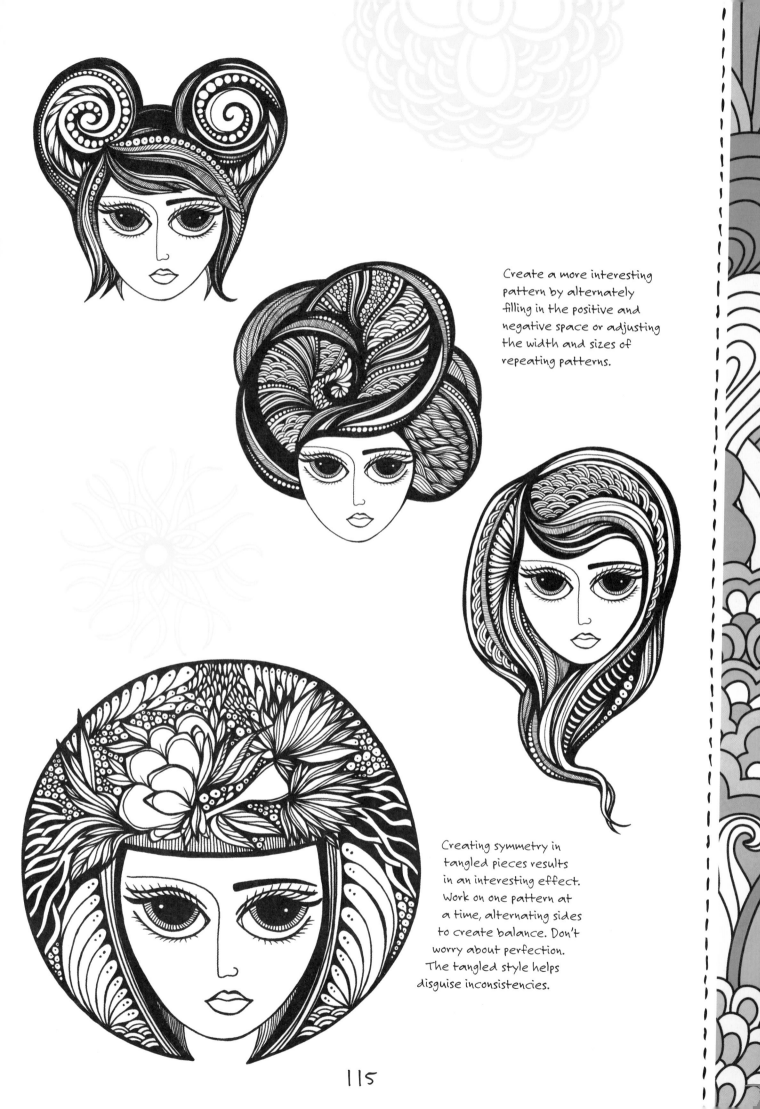

Create a more interesting pattern by alternately filling in the positive and negative space or adjusting the width and sizes of repeating patterns.

Creating symmetry in tangled pieces results in an interesting effect. Work on one pattern at a time, alternating sides to create balance. Don't worry about perfection. The tangled style helps disguise inconsistencies.

115

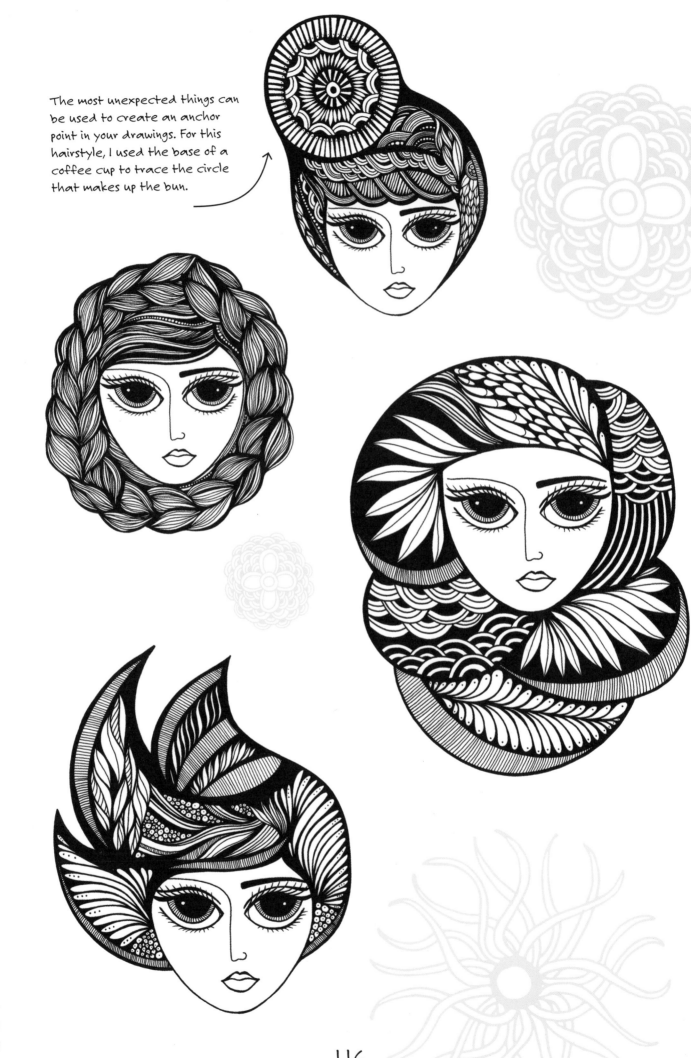

The most unexpected things can be used to create an anchor point in your drawings. For this hairstyle, I used the base of a coffee cup to trace the circle that makes up the bun.

116

PRACTICE HERE

Give this face a wild hairstyle!

Tangled Accessories with Penny Raile

Tangling and doodling don't need to be confined to paper. In fact, they are the perfect art forms to embellish all sorts of items. Brainstorm some things that you would like to tangle—a jacket, a t-shirt? How about sneakers or a fabric-covered headband? Tangling is also perfect for decorating notebooks, journals, binders, note cards, and stationery. This chapter will show you how to tangle a bracelet, a bead necklace, and a tote bag. But the sky is the limit, so tangle away!

Tips

• Carry a sketchbook wherever you go! When you see a pattern that catches your eye, sketch it. Patterns can be found around every corner—from cafés to traffic lights!

• Find time to tangle and create. You are only as creative as you make time for! Perhaps Sunday mornings are a good time to sketch, tangle, and come up with your best ideas. Or allow yourself a few minutes each day to enjoy some downtime with a pen and pad.

• Sign and date your artwork. Even better—authenticate it by indicating where you were when you finished your piece. In a coffee shop? On a plane?

Fashion-spiration!

Tangled borders are perfect for embellishing wide wooden bracelets and beaded necklaces (like the projects featured in this chapter). Look at the ideas below; then either practice what you see or create your own tangled borders.

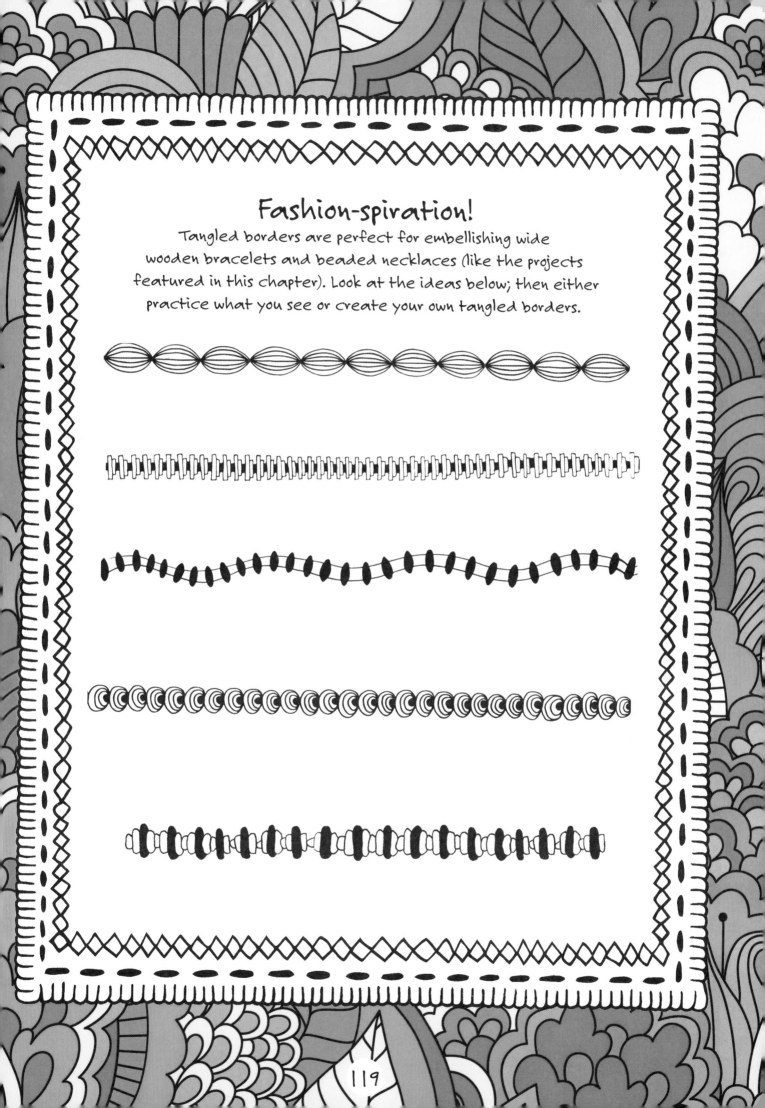

Tangled Necklace & Bracelet

With a bag of unfinished wooden cuffs and a thrift store necklace, you can make a fun and stylish tangled necklace and bracelet.

Use a knitting needle or chopstick to hold the beads in place while you draw patterns on them. Use two to three coats of glossy varnish to seal the wood. Let dry for 18–24 hours; then string the beads onto leather cord. Use additional beads between the tangled beads.

MATERIALS
- Wooden cuff
- Wooden beads
- Necklace or cording
- Archival ink pen
- Chopstick or knitting needle
- Varnish (glossy)

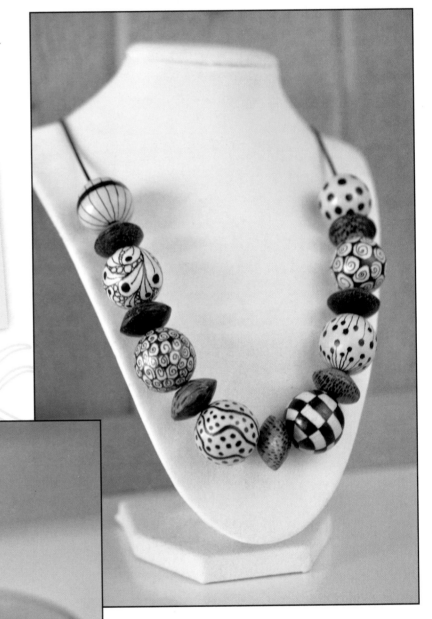

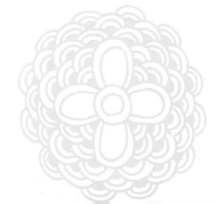

Use any of the tangles in this book, or make up your own patterns, to embellish your accessories.

Tangled Tote

It's easy to create your own canvas tote, or you can purchase a blank tote for an even easier project.

MATERIALS
- Blank canvas tote or canvas material (black and white)
- Needle and thread (optional)
- Fabric pen

Sewing the Tote

If you choose to make your own tote, cut four 7" x 6.5" white canvas rectangles and four 7" x 6.5" black canvas rectangles. After tangling on the white rectangles, create two larger rectangles by sewing a black piece and a tangled piece together. You will sew the two larger rectangles together in a checkerboard pattern. Repeat with the remaining four rectangles. Follow any simple tote pattern to create the bag.

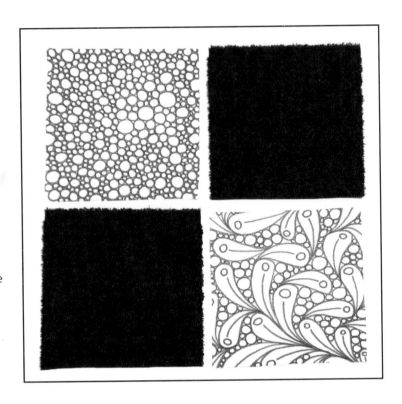

Tangling the Tote

Use a fabric pen to fill the canvas panels with tangles of your choice. Review the designs on pages 9–23 for inspiration.

122

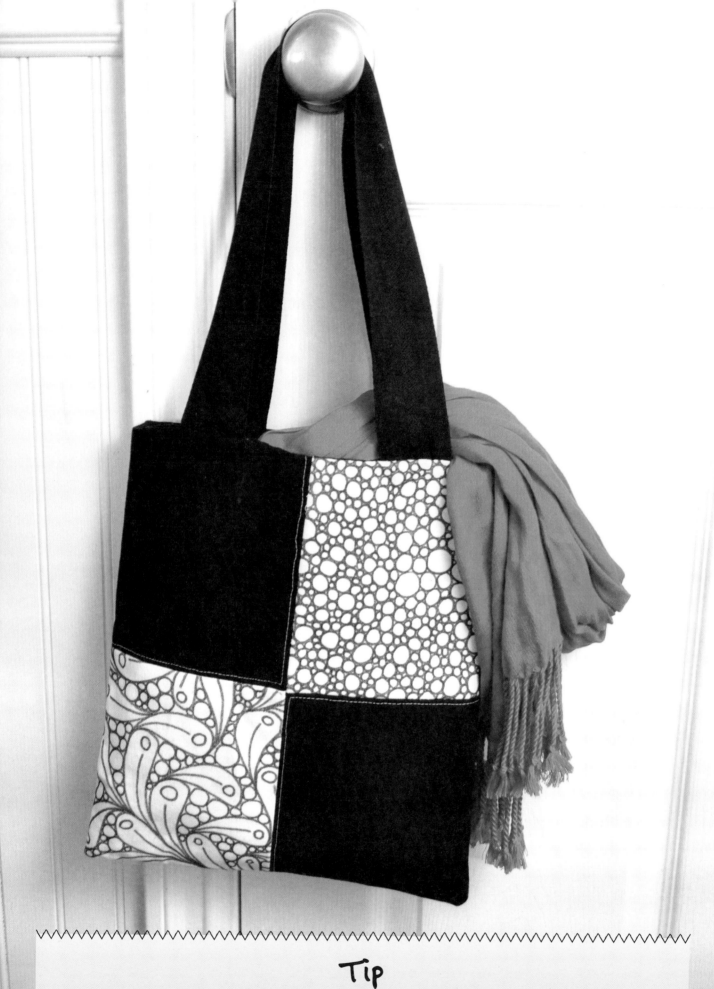

Tip

If you like, draw your designs lightly in pencil first, and then ink over them. You can't erase an error in pen from the fabric, but don't worry if you make a mistake. Simply rework it into your design—that's the beauty of tangling and doodling!

Tangled Pyrography with Monica Moody

Now that you've tangled and doodled your way through the prompts and projects in this book, you're ready to take your fashion-tangling prowess to the next level. There are many resources devoted to pyrography, where you can find a wealth of detailed information and woodburning instructions online and in books.

Safety First

• Where there's smoke, there's fire, and where there's pyrography, there's smoke! Take precautions to ensure you are not inhaling smoke as you burn. A well-ventilated area is helpful, but a fan (blowing the smoke away from you) and a respirator are recommended for safety.

• Be mindful that burning wood may affect not only you, but also the people around you.

• Smaller details and intricate patterns can be more difficult to burn. Remember to watch out for your fingers. Thin wood and the small size of this project can make you susceptible to burning yourself if you don't work carefully and alertly.

Pyrography Fundamentals

Tools

There are many brands of burners available, but most are one of two types:
1) Inexpensive single- or variable-temperature "solid point" burners that resemble a soldering iron, typically found in craft stores and often in kits with interchangeable tips or nibs; and 2) "Hot wire" machines, which consist of a base unit with adjustable temperature dial(s) and separate woodburning pens that plug into the unit.

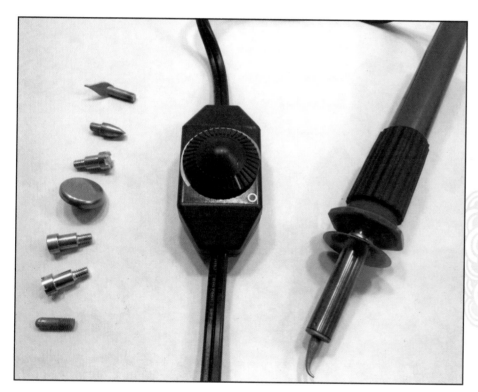

Variable-temperature, solid-point burner The tips are interchangeable, but the burner must be completely cool before the tips can be removed and replaced (at left).

Variable-temperature hot-wire machine with interchangeable fixed-tip pens This particular unit from Razertip® is a dual burner, which makes switching pens quick and convenient, although the pens cannot be used simultaneously. There are many types of pens available for Razertip® burners and other brands. I use skews and shaders more often than pens (at right).

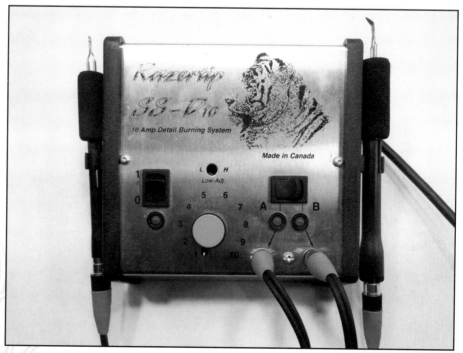

Tangled Leather Cuff

Dress yourself in style with these fashion-forward tangled leather bracelets. You can draw your own design directly on the leather with a pen or dark pencil, or you can use graphite paper to transfer a design. For this project, I drew and transferred my designs before burning them onto the leather.

MATERIALS
- Paper
- Pencil or pen
- Graphite or transfer paper
- Scissors
- Leather bracelet/wristband blanks*
- Woodburning tool

*Note: You can find leather wristbands at your local hobby store and online. I used two medium-size (1.25" x 9") wristbands for this project.

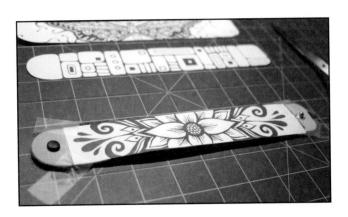

1 Cut out your design and a piece of graphite transfer paper to fit your bracelet, and tape them down. The graphite paper should be under the design with the dark side facing the leather.

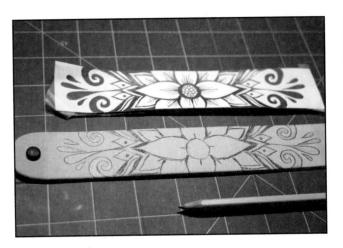

2 Use a pencil to trace the design and transfer it to the leather. I left out some of the details in the sunflower on purpose; some things are easier to burn without tracing first.

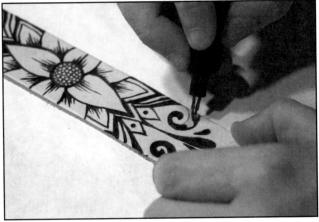

3 Burn the design into the leather using an extra-small skew pen. I used a circle stamper in the center of the flower.

Tip

Leather burns at a lower temperature than wood. You will also need to clean the tip of your woodburning pen more often than you do when burning wood. I use a Razertip® cleaner, which has tiny razor blades to remove debris from pen tips.

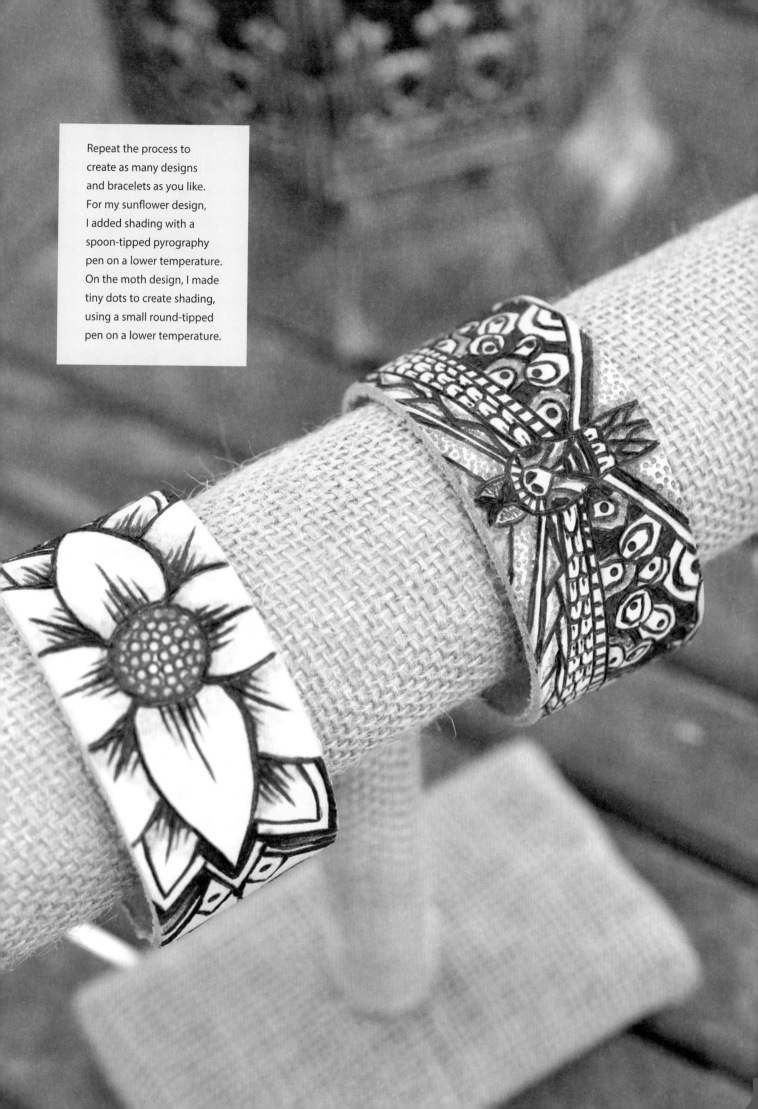

Repeat the process to create as many designs and bracelets as you like. For my sunflower design, I added shading with a spoon-tipped pyrography pen on a lower temperature. On the moth design, I made tiny dots to create shading, using a small round-tipped pen on a lower temperature.

Bracelet Templates

These templates are designed for medium-size leather bracelets (1.25" x 9").
To create a template for another size, simply lay the bracelet on a blank sheet
of paper and trace. Then fill in the outline with your design.

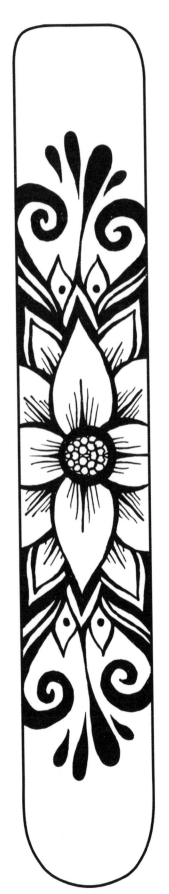 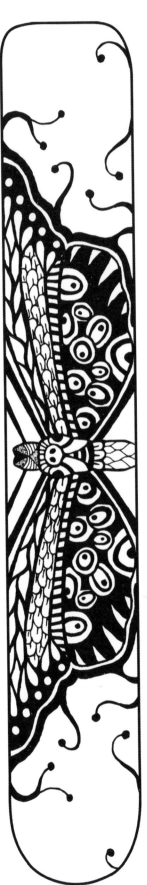

Use the blank templates below to create your own cuff designs.

Tangled Woodburned Necklaces

When tangling on wood, I usually draw directly on the wood with a pencil before burning. For this project, I created a few designs (which you are welcome to try) to demonstrate how to transfer an image to wood for burning.

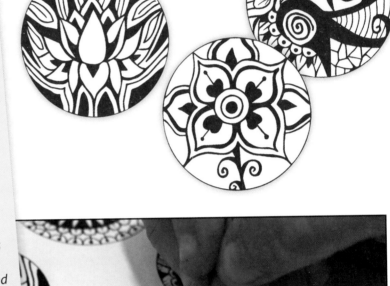

MATERIALS

- Paper
- Pencil or pen
- Graphite or transfer paper
- Archival ink pen
- Scissors
- Wooden circles (mine are 2" in diameter)
- Wood-burning tool
- Waxed thread, hemp, leather cord, or a chain
- Sealant*

*Note: Seal your completed pieces with a sealant, such as polyurethane, clear fixative spray, varnish, Danish oil, and beeswax polish.

1. Start by drawing or printing a page of circles to use as templates. Sketch your designs in pencil, and ink over them with a pen.

I used these fixed-tip pens to burn the necklaces: an extra-small skew pen for thinner lines and details (above left); a triangle-shaped shader-tip pen, which I turn on its side for lines and use flat for darkening solid areas (above right).

2

Cut out the tangled templates, as well as small pieces of graphite paper to transfer the designs to wood.

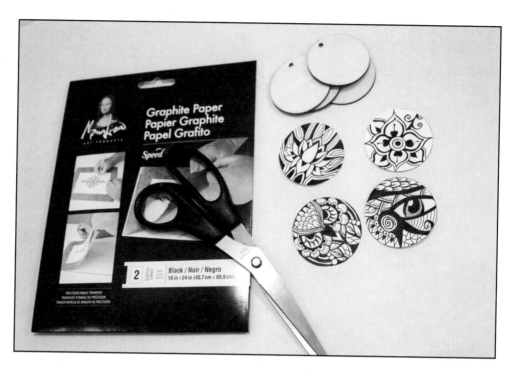

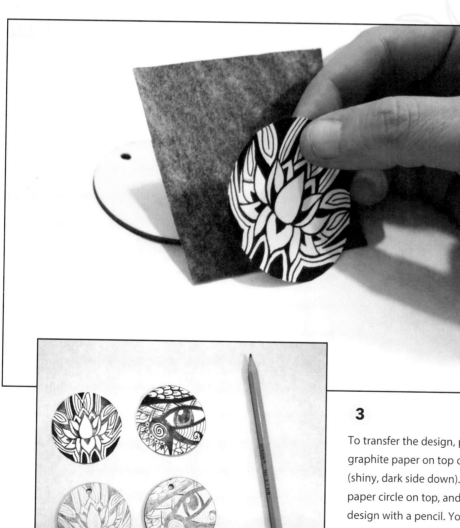

3

To transfer the design, place a piece of graphite paper on top of a wood circle (shiny, dark side down). Then place the paper circle on top, and trace over the design with a pencil. You may have to complete the smaller areas with pencil after removing the graphite paper.

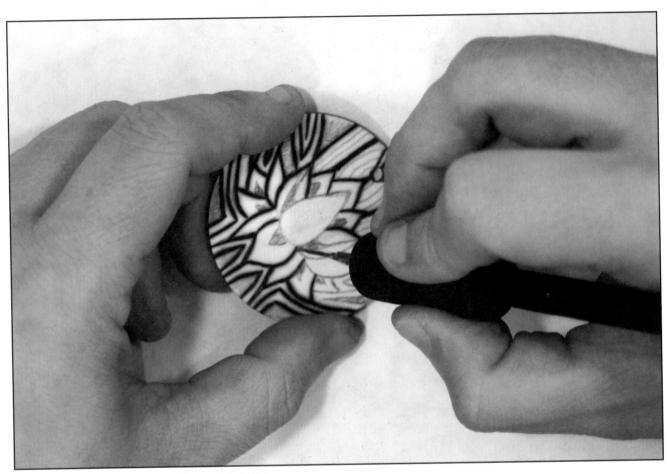

4 Use an extra-small skew pen to burn the lines and small details of your design.

Tip
I like to finish woodburned pendants with two light coats of satin-finish Polycrylic® to seal and protect.

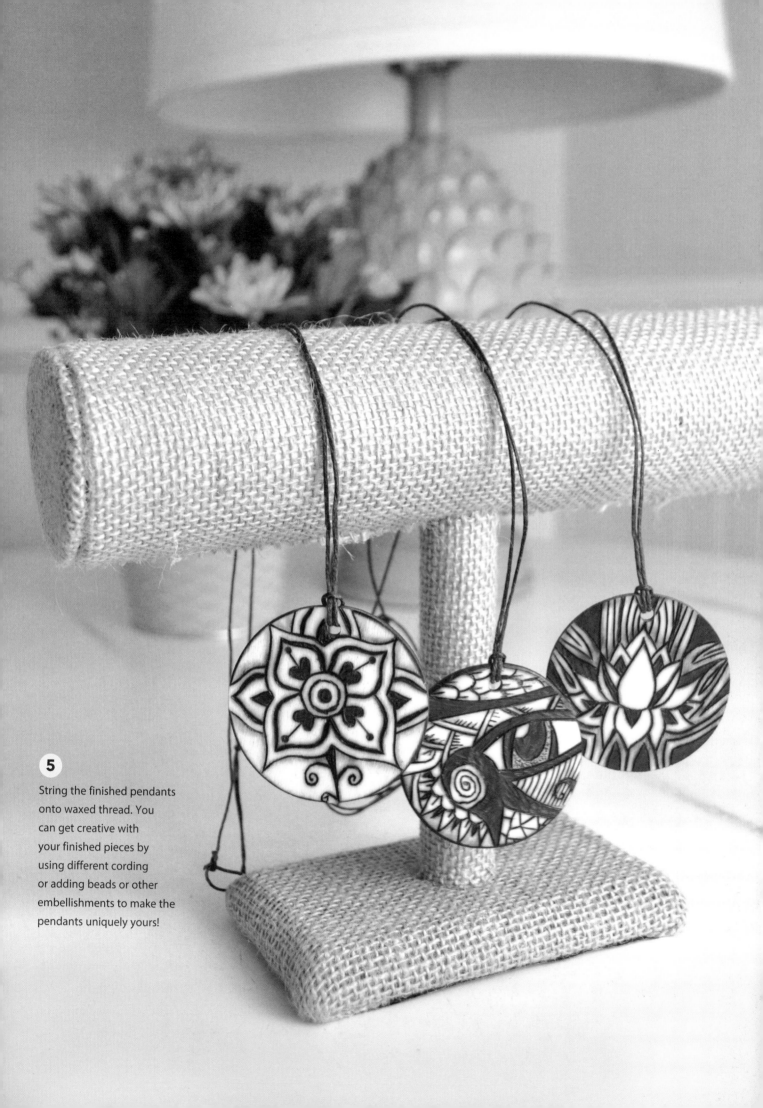

5

String the finished pendants onto waxed thread. You can get creative with your finished pieces by using different cording or adding beads or other embellishments to make the pendants uniquely yours!

PRACTICE HERE

Use these blank pages to work out your project design ideas.

Nailed it!
with Lisa-Mari Grytten

Tangled and doodled nails are the perfect way to share your love of tangling with the world. Follow these tips and instructions to create your own terrific nail designs!

MATERIALS
- Opaque white nail polish
- White and black acrylic paint
- Nail detail brushes
- Dotting tools
- Matte top coat

1

Apply an opaque white polish to clean nails. Use two coats if needed, and let dry completely.

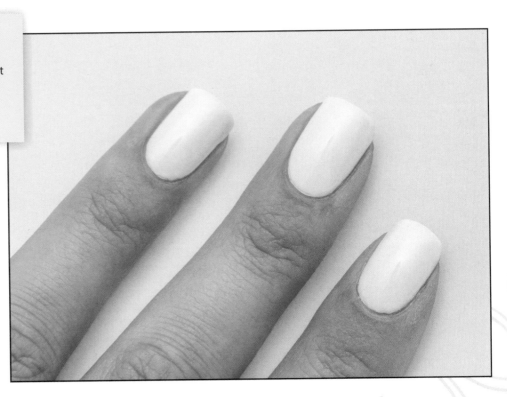

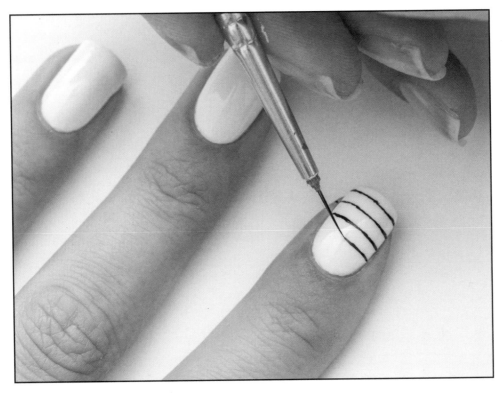

2

Use black acrylic paint and a very thin paintbrush to paint evenly spaced horizontal lines on your index nail.

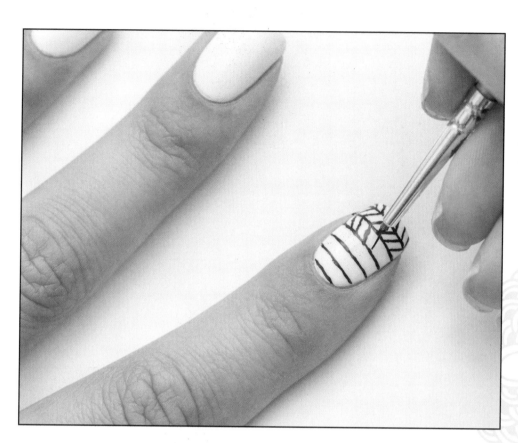

3

Use a tiny brush with short bristles to paint angled, evenly spaced lines between the horizontal lines. Alternate the direction of the lines every other row.

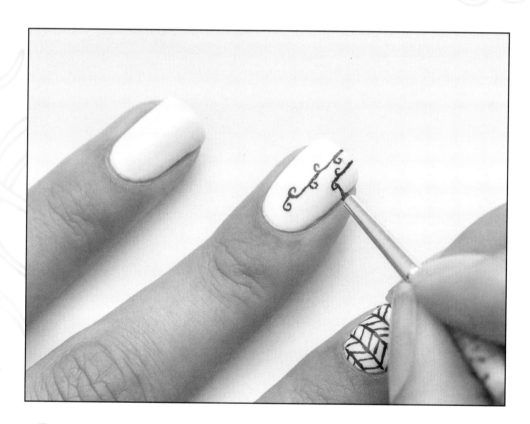

4 Paint a short, straight line on the middle nail, and add a little curl at the top. Repeat the pattern until you are happy with the look. Alternate the direction of the curls to add variation, if desired.

5

On your ring finger, paint thick half-ovals. Imagine an oval bull's-eye with the center at the edge of your nail.

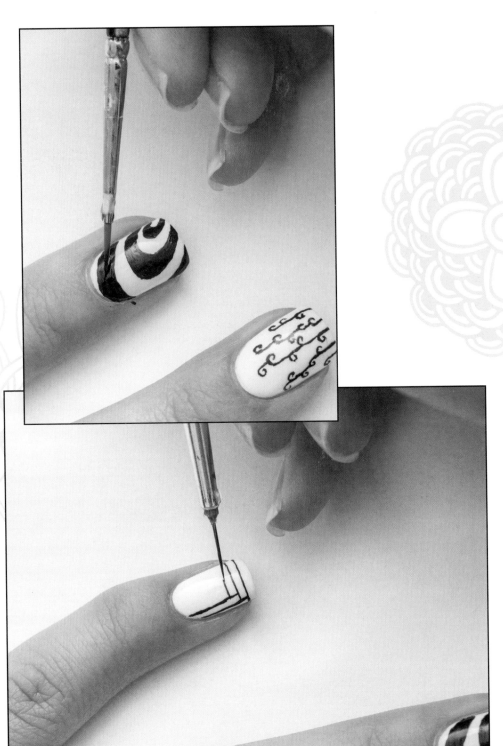

6

On the pinkie, use the thin paintbrush to paint a series of horizontal and vertical lines, keeping them evenly spaced.

Tip
Practice makes perfect, but nail art and tangling are about having fun, so don't worry about perfection!

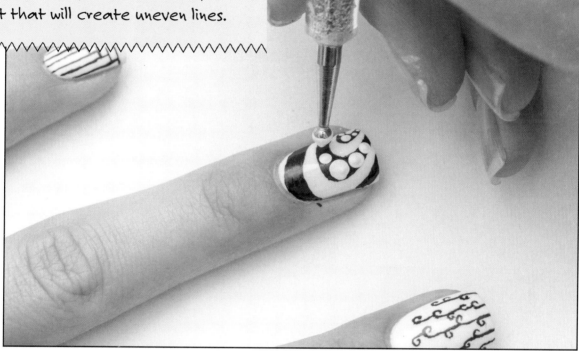

7 Use a dotting tool and white acrylic paint to add dots inside the black paint on your ring finger. Vary the sizes of the dots with different sizes of dotting tools.

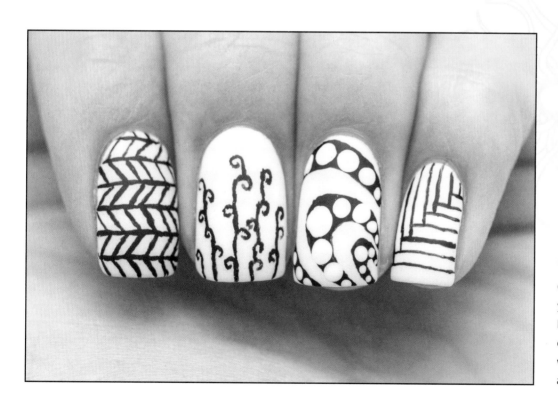

8

Clean up any paint on your hands using a brush or cotton swab dipped in water. Finish with a matte top coat, and admire your work!

Bridal Gown Templates

143

About the Artists

Jill Buckley

Transitioning from clothing designer to textile artist, Jill's fascination with line, pattern, and form has never wavered but evolved into the intricate doodles she is recognized for today. A self-taught artist, Jill worries less about "rule" and more about enjoying the process. She loves the freedom of discovering endless creative possibilities whether it is in fabric, stitch, or ink. Visit www.thequiltrat.blogspot.ca.

Norma J. Burnell

By day, Norma is a website designer. At night and anytime in between she's a "tangler." Norma likes to incorporate many of the patterns she sees in nature into her Zentangle®-inspired pieces, working from her original drawings and tangling them up. She also enjoys drawing and painting and has taught art classes to adults and children. Visit www.fairy-tangles.com.

Heidi Cogdill

Heidi is a storyteller. Whether with words or pictures, her aim is always to inspire through stories. Over the past decade, she has combined her love of the written word, fashion illustration, and doodles to create characters and illustrations that inspire the imagination. Visit www.heidicogdill.com.

Lisa-Mari Grytten

Lisa loves expressing herself creatively. She has been drawing painting, sewing, knitting, and photographing ever since she was a little girl—as well as playing with makeup and nail polish. Nail art is a way for Lisa to express herself and squeeze in some relaxation. Visit www.polishedelegance.com.

Monica Moody

Monica Moody is an artist from Dallas, Texas. Known for her vibrant alcohol-ink paintings, Monica also enjoys mixed media, illustration, relief printmaking, pyrography, and watercolor painting. Visit www.monicamoody.com.

Jody Pham

Jody is an artist living in Dallas, Texas. Her distinctively monochromatic ink illustrations are inspired by nature, human anatomy, and the intricacies of everyday things.

Penny Raile

A talented Zentangle® artist, Penny is known for her whimsical designs and spirited use of color. Her downtown Los Angeles loft, with turquoise-stained floor and hand-painted walls, reflects an eclectic mix of paintings, sewn dolls and creatures, dioramas, polymer clay objects, cardboard cuckoo clocks, and WhimBots crafted from thrift-store finds. Visit www.tangletangletangle.com and www.raileytypepad.com to learn more.